iPHONE
PHOTOGRAPHY
FOR EVERYBODY

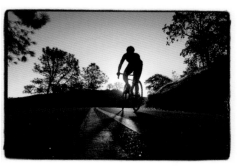

Michael Fagans

AMHERST MEDIA, INC. ■ BUFFALO, NY

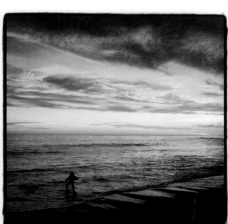

Acknowledgments

An enormous thank you to my wife, who fortunately handles being married to a photographer with grace. Big thanks to my brother Joshua for inspiring me with his work and collaborating and encouraging me in mine. Much love to Mum for planting the spark. Thank you Nalani and the Not-So-Little-Guy for providing daily reminders about why life is precious. This could not have happened without all of my photographic mentors, known and unknown, named and unnamed. Thank you.

Copyright © 2017 by Michael Fagans
All rights reserved.
All photographs by the author unless otherwise noted.

Published by:
Amherst Media, Inc., PO Box 538, Buffalo, NY 14213
www.AmherstMedia.com

Publisher: Craig Alesse
Senior Editor/Production Manager: Michelle Perkins
Editors: Barbara A. Lynch-Johnt, Beth Alesse
Acquisitions Editor: Harvey Goldstein
Associate Publisher: Kate Neaverth
Editorial Assistance from: Roy Bakos, Rebecca Rudell, Jen Sexton-Riley
Business Manager: Adam Richards

ISBN-13: 978-1-68203-290-9
Library of Congress Control Number: 2017943282
Printed in The United States of America.
10 9 8 7 6 5 4 3 2 1

www.facebook.com/AmherstMediaInc
www.youtube.com/AmherstMedia
www.twitter.com/AmherstMedia

Contents

About the Author

Michael Fagans enjoys telling people's stories. His journey has taken him to the Navajo Nation, Malawi, India, Afghanistan, Scotland, Austria, Canada, the Dominican Republic, Belize, and Guatemala.

Michael is a graduate of the Rochester Institute of Technology and currently works as an assistant professor at the Meek School of Journalism and New Media at The University of Mississippi. Previously, he served as Director of Strategic Communications for the United Way of Kern County, as the Coordinator for the Kern Coalition Against Human Trafficking, and as the Assistant Photo Editor at *The Bakersfield Californian* where he focused on multimedia, video, and web projects.

Michael is a founding member of www.risingtideproductions.tv and co-producer and director of the documentary film *The Trafficked Life*. He is also the National Press Photographers Association's Photographer of the Year for 2005 for New York state and Ontario and Quebec provinces.

Michael is married to the Rev. Deborah De Boer and lives in Bakersfield with their daughter, foster son, and two cats.

www.michaelfagans.com
www.facebook.com/michael.fagans
www.twitter.com/skip_fagans
www.vimeo.com/michaelfagans

Author photo by Irene Randolph.

1. The Everyday World

One of the hardest things for me to inculcate in students is the ability to explore their world visually. When they get it, though, look out! Suddenly, they start discovering little details, moments they hadn't seen before, and how the light changes. All of these things make for interesting photographs before you even leave your house or neighborhood.

■ Shift Your Perspective

The photographer Joel Meyerowitz summed this up perfectly for me many years ago when he lectured at my school, the Rochester Institute of Technology. He said, "If you see the world from even two degrees of difference, it is a whole new world." I believe that he is absolutely right. Every time I learn something new, or think about things differently, there is an entirely new world out there for me to explore visually.

■ A Receptive Mind

One of my favorite parts of the day is walking our daughter to school because I can just listen to whatever she wants to talk about. But I am also watching her and looking around our neighborhood. She, my wife, and even my larger family are used to me stopping and looking at something or dropping out of a conversation. I am grateful that they put up with my behavior (or that they excuse my behavior or simply ignore me—pick whatever story works best for you!).

But it is that time, early in the morning, before my brain is working—or I should say, before my *thinking* brain is working—when I can make connections or see things without dismissing them immediately. In one sense, my internal editor is turned off; my brain's filters have not yet engaged and so things are fresh and interesting to my eye. The trick is bringing that mindset with you wherever you go during the rest of the day.

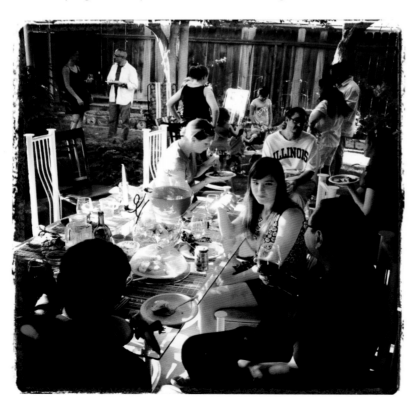

■ Find the Hook

The saying "the devil is in the details," holds a fair amount of power in my life. It is those little things that can make or break a photograph. My Photo 1 teacher from Brazil, Millard Schisler, called them "hooks" in photographs—the small things that catch and hold our eye in an image. They can work for us if they are the place where our gaze lands, and they can work against us if viewers' eyes don't get to where we want them to go.

■ Complexity (facing page)

My wife fell in love with the backyard of our house when she saw the pictures of the porch. We have, over the years, made it into a place where we can entertain friends and family. Food and conversation are a big part of what makes those events successful and (like the image on the opposite page) that's because there are multiple levels. The dark foreground helps frame the bottom of the photograph and those people are talking to one of the subjects in the light. The table works as a strong diagonal, leading our gaze to another group of people engaged in conversation, and then the background fence keeps our gaze from leaving the frame.

■ Simplicity (above)

More simply, a simple pencil drawing becomes interesting when I crop down to the lone figure, sinking or swimming in something. The look on his face and the gesture of his arms convey a real sense of urgency. The photographer in me knew that adding a diagonal to the image would give it some energy. (However, camera tilts can also be overused; in fact, one of my mentors, Greg Dorsett, is probably wincing as he looks at this image!)

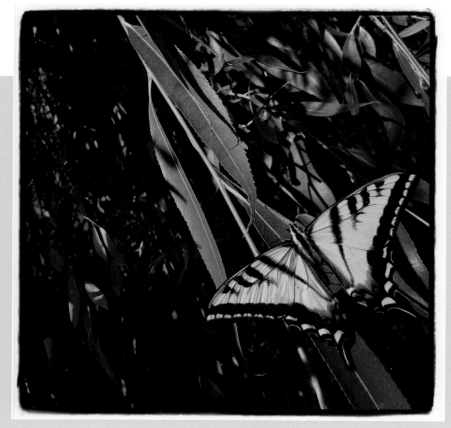

■ Sidewalk Drawing *(top left)*

This is the sidewalk leading up to our house. Our daughter loves drawing on the sidewalk with chalk, and it's especially meaningful to me because that was the first activity we shared with her when she came to our house as a foster child. What is interesting in this image is that the sprinklers watered the lawn (and the concrete), so the chalk became much more like pastel or watercolor.

■ Warming Its Wings

This butterfly was warming its wings in the sunlight during our walk to school in the morning. I like that the blue on the wings is matched by the blue sky peeking between the leaves.

■ Water Sculpture

This water sculpture was outside the exercise room at a hotel I was staying at. I really like the sense of movement and blurring of the background. Abstract images can work well when we give the viewer enough hints.

■ A Study in Contrasts (below)

Strong leading lines, edge lighting, and a muted color palette all work together here. What really adds something for me is the seagull at the bottom right of the frame. The visual weight of the Ferris wheel contrasting with the ease and flight of the bird makes this image interesting for me.

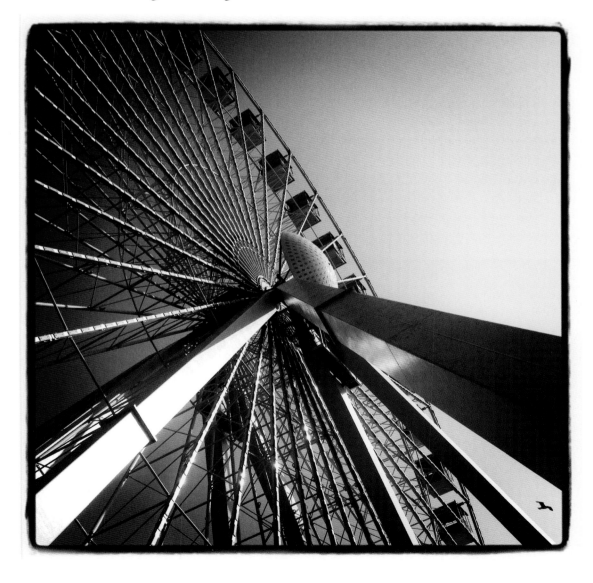

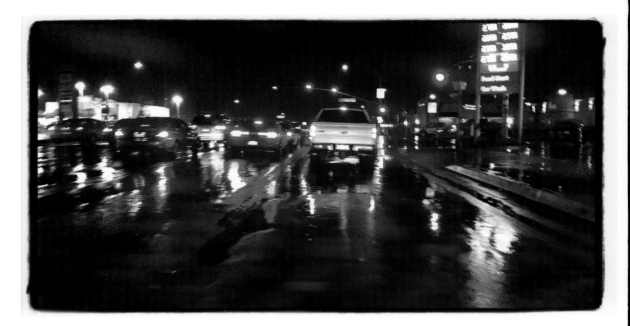

■ Try Something

I like to take chances from time to time, especially since pixels are free. Right? There is no cost in taking an individual picture (yes, I know the phone or camera cost something and if we have a bad calling plan things get worse) but, at the end of the day, it can't hurt to try something.

So I asked myself, what would happen if I was moving my phone as I took the picture? And look what happened. The rain drops that were visible on my car's windshield are not noticeable with the movement. Yes, the edges of the cars are softer, but that adds to the mood and feeling of the image.

The other critical part was postproduction. Compare the original capture *(below)* and the finished one *(above)*. Cropping out the sign at the upper right of the image helps keep our eye in the frame and so we continue to explore the photograph. Keep an eye on those details.

❝I asked myself, what would happen if I was moving my phone as I took the picture?❞

"The yellow and red at the tips of the leaf really come forward."

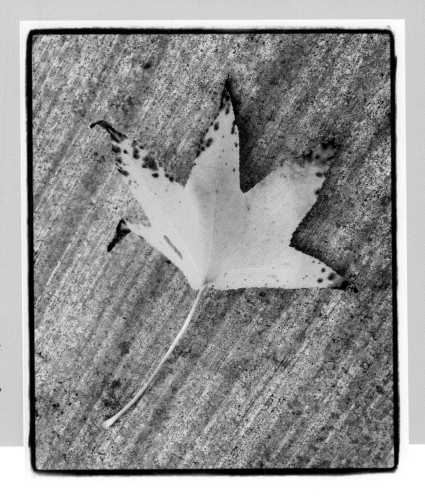

 Colors That Pop

The simple gray of the sidewalk really makes the colors of the leaf "pop" for me. Ironically enough, the camera's metering tries to make everything 18 percent gray. The white streaks throw that off here, yet the yellow and red at the tips of the leaf really come forward. Again, the color contrast of the materials, leaf, and sidewalk makes this interesting.

■ **Filters** (bottom right)

In my first book, *The iPhone Photographer*, I talked about and used a lot of filters from the Hipstamatic app. I can promise you that this is one of the few uses of those filters in this book. Hipstamatic helped me "strip down" my photography from my professional cameras, but these days I primarily use my iPhone's Camera app. In this case, Hipstamatic's filters (D-Type Plate Film with the Tinto 1884 Lens) helped me add an atmospheric feeling to the beach image.

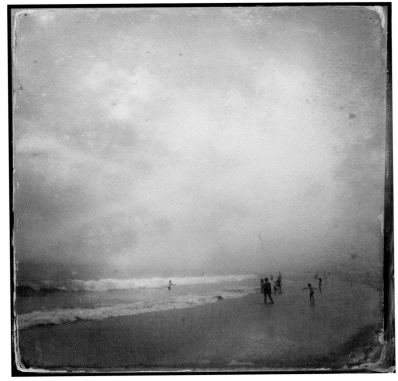

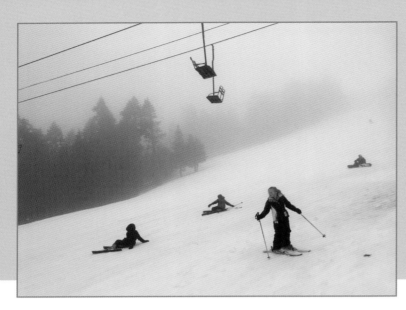

■ Adding Layers

I am a big fan of adding "layers" to your images. In this photograph, there is a foreground with the single skier standing up, a middle ground with the three skiers on the ground and the chairs above them, and then the trees fading off into the mist. Together, they provide a sense of depth and place.

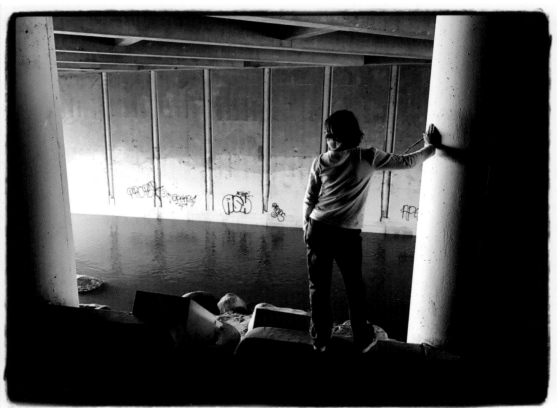

■ Framing (above)

Concrete is used in this image to provide framing within the frame. I like the anticipation of what might happen next. Is this person surveying the area before jumping down? What do they see to the left? I get a sense of adventure. Good photos ask questions that may not be answered within the image.

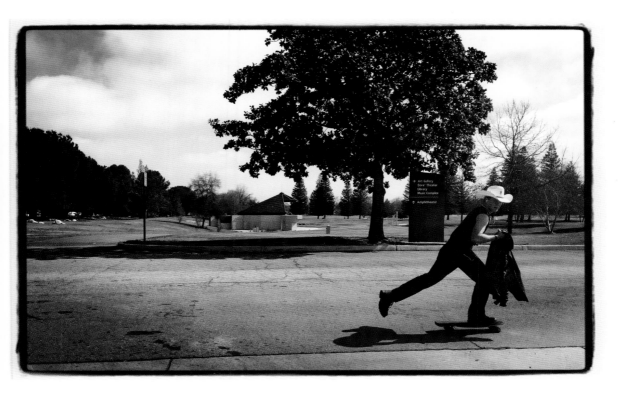

■ Juxtaposition (above)

I like juxtapositions, especially a man in a cowboy hat on a skateboard. I saw him coming from my left and barely got my phone up in time. I like the gesture of his back leg as he pushes off, the sense of movement to our right—and that he is looking back at us. You may be able to tell that we are on a college campus (based on the signage in the background) but it doesn't especially matter where we are; it is just an interesting moment from life.

■ The Level of Your Subject

Why did the tarantula cross the road? (I am sure there is a joke in there somewhere . . .) Here in California, especially on the back roads in the San Joaquin Valley, this is not an unusual sight—at least, you see it more frequently than photographers lying down in the middle of the road! Don't be afraid to get on the level of your subject (although some of you with arachnophobia might disagree with me here).

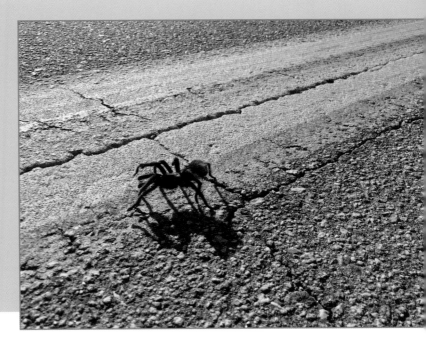

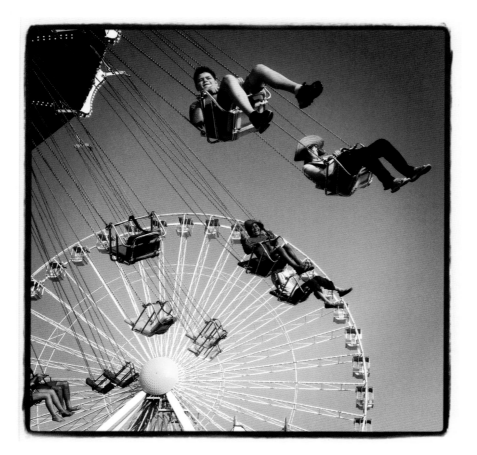

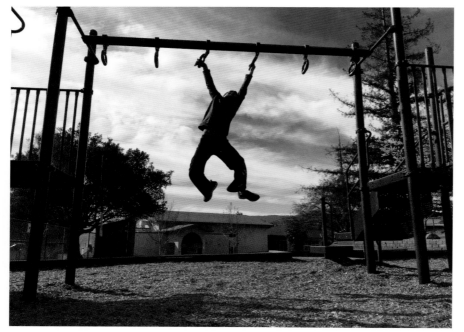

▪ Ferris Wheel

(top left)

Nothing says "boardwalk" like rides and a clear blue sky. The Ferris wheel had muted colors, but we get more spot color with the yellows and red. The diagonal of the swings and the sense of movement help make this image work. The framing and separation of the top two riders help guide our gaze and I love the two sets of legs coming into the frame on the bottom left.

▪ Motion *(bottom left)*

Freezing motion, or implying motion, is often dependent on the "decisive moment," as Henri Cartier-Bresson would call it. The jungle gym itself adds a framing element and the separation between the building and the child, highlighted against the sky, contribute to make this an interesting photograph.

■ Wherever You Are (right)

As you can tell, I don't mind taking a photograph from my car. The good news is that I framed up this image before the light turned green and people started to drive away. Getting that white truck at the bottom right of the frame really helps with the image—and the double rainbow was worth trying to get. Do I wish I had been somewhere more photogenic when this happened? Sure, but I wasn't. It's more important to take the picture when it presents itself than to wish you were somewhere else.

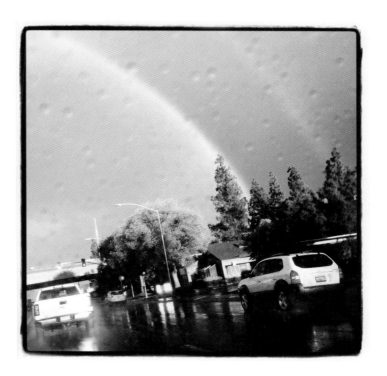

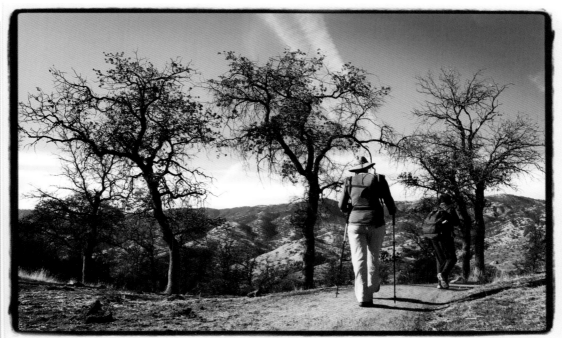

■ Patterns

Photographers are suckers for repeating shapes, patterns, and framing within the frame. Here my wife and daughter are headed down the trail and those three trees just make the image. The colors of their backpacks help add a little punch to the photograph.

■ Seasonal Discoveries

Another morning walk and another find. If you walk enough you start to notice things that happen seasonally. These flowers *(top left)* were beautiful last year and fell when there was amazing early morning sunlight. This year, nothing. So, once again, photograph something while it is there—don't wait for tomorrow, next week, next season, or next year.

These beauties *(bottom left)* were in a different neighborhood on a ride with friends. In 2017, California got an above average amount of rainfall in the winter, which we desperately needed. The upside to all the rain was an increase in flowers, both in people's yards and in the wild.

"Photograph something while it is there—don't wait for tomorrow, next week, next season, or next year."

■ Morning Light

(top right)

Early morning or late afternoon/evening light can be magical. That doesn't mean you can't make good images in the middle of the day, but your chances of great light are heavily diminished. There are reasons that the pros get up before sunrise, take a break, and then work until the sun sets. In the light of the setting sun, this autumn tree is aglow.

■ Summer Fun

(bottom right)

It might be a stretch for "everyday," but this is a perfectly normal weekend for us. Head to the mountains, bring the tubes, and float the Kern River in Kernville. I love the spot color pink and the strong foreground and midground. If you know anything of Kernville, you know that there is no contributing background on the other side of the river at this spot. Composing the image to exclude it made the shot stronger.

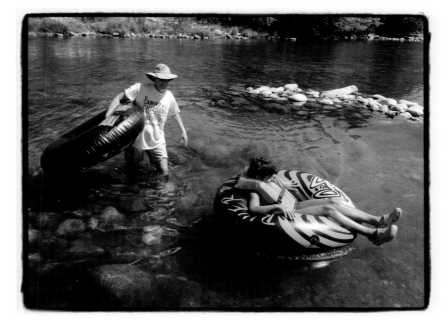

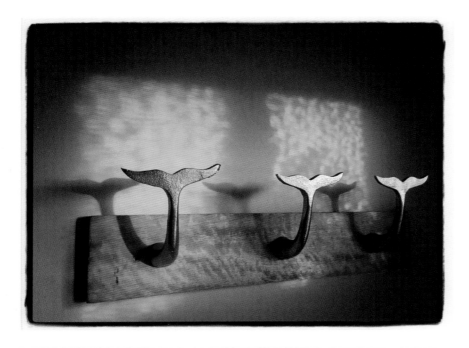

■ One Moment, Two Shots

This was one of those times that I am sure my family just looked up, shook their heads, and went back to dinner.

The light shining through the windows perfectly lit these delightful coat hangers in the shape of whale's tails *(top left)*. This magical moment happened for maybe 30 seconds and then it was gone. The repetition of shapes really helps this image.

When something catches your eye, don't forget to look behind you, too. This was a hard-learned lesson early in my career and I still forget it from time to time. It was the light on this wall that initially caught my attention that day—and this was the first image I took *(bottom left)*. I shot the whale tails image second, but I actually like it better. Shoot first, edit later.

■ Placing the Horizon

I like to say the rules of photography are more like guidelines (riffing off the *Pirates of the Caribbean* movie). One of the "rules" you should know, though, is the rule of thirds. Imagine there are lines in the frame that divide it into thirds (like a tic-tac-toe grid). By placing your subject on one of those lines or at an intersection of two lines, you're likely to create a more effective composition.

 Putting the horizon at the top or bottom third of an image really helps. When you place the horizon in the middle of the frame you effectively cut it in half. Of course, that might really work some day, so don't let that become a rule; it should be a guideline. I am much more likely to bend or break a guideline than a rule. (*Note:* The police feel differently about laws by the way; neither this book nor my opinions will be enough to help you in a court of law—just saying.)

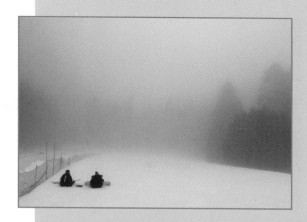

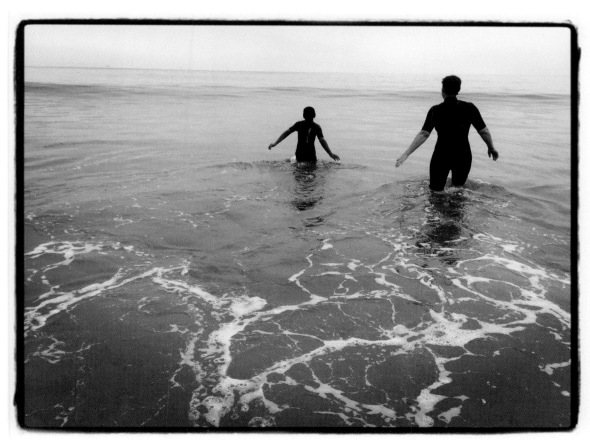

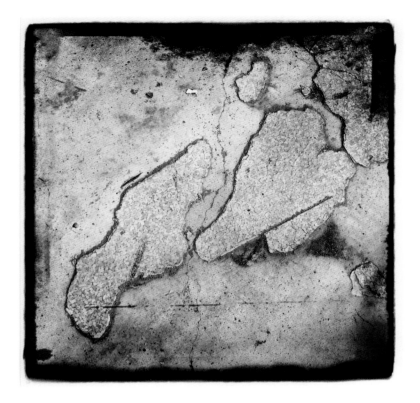

■ Interesting Abstracts

(top left)

Is this a cool map of some islands? An aerial photograph? Something else entirely? Best I can tell, it is formica that was laid down on concrete at a gas station that was subsequently demolished. The floor covering was then weathered by the sun and elements. So, do you get my point? Does it matter what this "really" is? Make interesting images.

■ Cool Shadows *(bottom left)*

Yes, I was probably late to work that morning—but the shadows and light in our house were really cool. I hadn't noticed the light doing this in our hallway before, but it grabbed my attention that morning. The vertical stripes and the graininess of the image are all working together here. This is about the only way I don't look like an unmade bed when I am all dressed up.

"The vertical stripes and the graininess of the image are all working together."

"It is hard to beat the appeal of the connection between land and sky when making images."

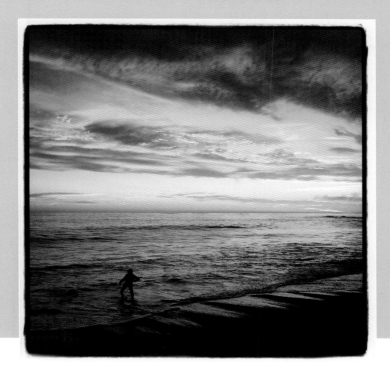

■ Beach Silhouettes

As you can probably tell, my family likes to go to the beach from time to time. Actually, my wife loves the beach and I go along with my camera or body board. I like to say that "none of my people tan," which is the truth—although it is hard to beat the appeal of the connection between land and sky when making images. That transition zone, depending on the time of day and light, does so many magical things.

Silhouettes on the beach have a great deal of strength, especially when compared to the vastness of the ocean. Throw in great light, soft light, or even noonday light and you can make an image that you cherish.

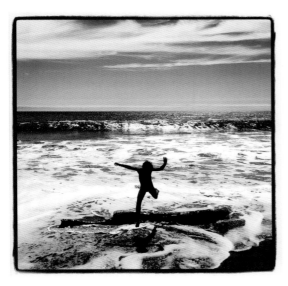

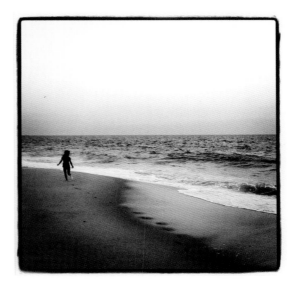

2. Life Happens

Part of my work these days is with United Way of Kern County, and the Kern County Homeless Collaborative is part off our offices. That means once a year I have the opportunity to go out on the Point in Time Count that takes place nationally. This is an effort by the Department of Housing and Urban Development and local communities to get a sense of how many homeless people are in the country and in our communities.

Volunteers get up at zero-dark-thirty to team up and head out and survey the homeless in our community. It is voluntary, so people are not requited to answer any questions.

Many of our homeless population sleep along the Kern River in Bakersfield. For this outing, my team of four people wandered into homeless encampments and verbally knocked on the doors of tents people are using for shelters. It kind of feels like you are walking into someone's living room—with all the things that are found in and around people's living spaces.

■ Metal Angel (below)

Finding a metal angel (almost a carbon copy of the one we use to top our Christmas tree) and then the American flag proudly displayed in the back sends a complicated message for our times.

In my head, this angel is looking over the encampment—as is the American flag. Angels

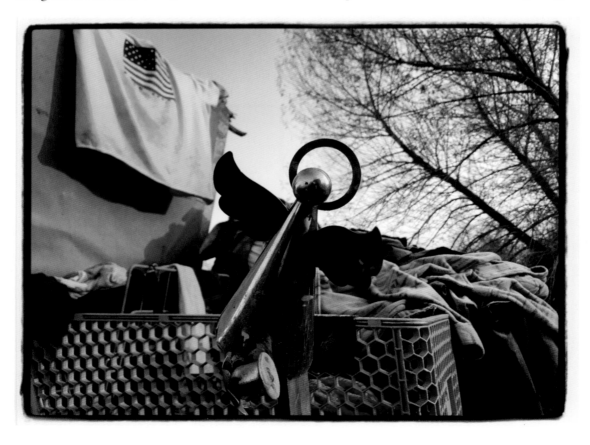

have become somewhat domesticated in our culture these days; people think of them as friendly, helpful, or protective. But if you read the Old Testament, you start to notice that the first thing angels tell people is, "Do not be afraid." My guess is that angels wouldn't have to do that if they weren't frightening in some way. So, if this is an Old Testament angel, looking over an encampment, what should we be afraid of?

I do not ask that question lightly.

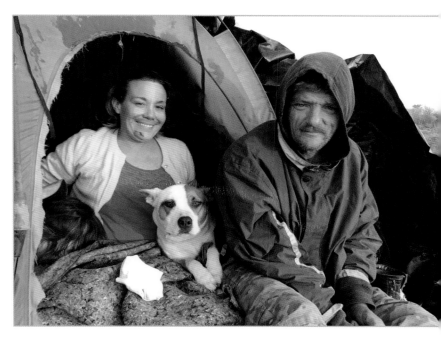

■ Human Kindness (top right)

I have met some of the most human of beings, and experienced some of the kindest gestures and relationships, while out participating in the survey. I have witnessed people share what little they have. I received offers of a seat or food. I have watched people looking out for and protecting each other. I have seen kindness in a hug or a touch.

This couple's story is like many others I have heard out in Bakersfield and around our country. And yet, they welcomed me into their lives for a few minutes after the Point in Time Count. I am always very careful and hesitant when asking people to let me take their photograph. I explain that we use the images to explain what we do as a nonprofit and how they can help get the word out about homelessness. But I also say that they can tell me to get lost. I don't want them to feel obligated to let me do this, but I would like to collaborate with them.

A lot of people decline, but some say yes. I think that matches my average in life. If you honestly talk to people, recognize their humanity, and honor your relationship in that moment, magical things can happen. We may never see each other again, but for that brief moment we are just three people having a conversation alongside the river. There is not a divide between housed and homeless. As I observed earlier, I have witnessed more humanity along the river than I have in some meeting rooms. I have experienced more honest conversations among those who have little than I have in some churches.

I don't make that observation lightly either.

> **❝I have witnessed more humanity along the river than I have in some meeting rooms.❞**

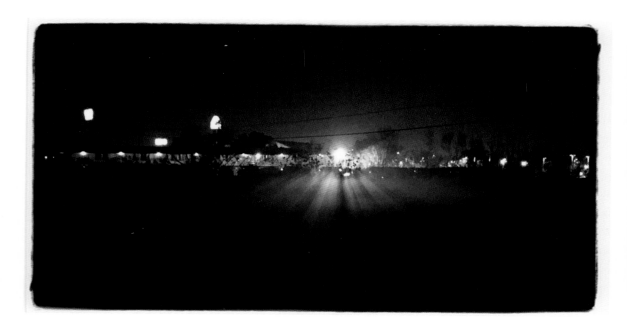

■ Before Dawn (above)

Getting up before dawn also means that I push my image sensor to the edge of its limits, if not beyond. That is where the fun lies. Here steam rises out of the riverbed. In situations like this, I work to stabilize my arms and also take multiple images to increase my chances of getting something without camera shake. I really like how the light is broken up by the objects along the opposite bank of the river.

■ Exposure Challenges (below)

In this photograph, two volunteers are surveying a homeless gentleman who was living under an overpass with a friend. In addition to working to mitigate camera shake, I also had to work on not overexposing the volunteers; the rest of the frame is so dark that it was throwing off the camera's exposure meter. For the most part, camera meters are really sophisticated, but there are times when you have to be smarter than the camera and the meter. In this case, the Manual app was my best friend.

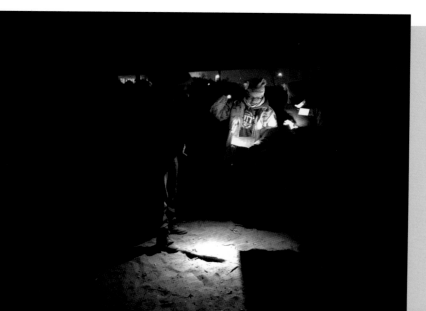

"There are times when you have to be smarter than the camera and the meter."

■ Staying Together (right)

This couple was sleeping right next to our office in town. So the Director of Homelessness Resources and I brought some water and power bars with us and tried to find out if we could provide assistance. Those of you with any experience in these things will know that we could not get them into a shelter as a couple (the only openings were in programs for men and programs for women), so these two choose to stay together. Life often gives people impossible choices. The hardest part for me is trying to help and, yet, honoring the decisions they arrive at—even if I don't agree with their choices.

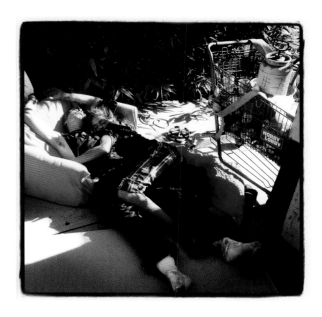

■ Portrait of Albert (below)

I met Albert while doing a story about people who had benefited from the ReGIVE Project that we run at work. People donate new or gently used house items or supplies, and people moving into a home or apartment for the first time can get things they might not have had out on the street. Albert has a very interesting story and he was comfortable with me taking a portrait outside his home.

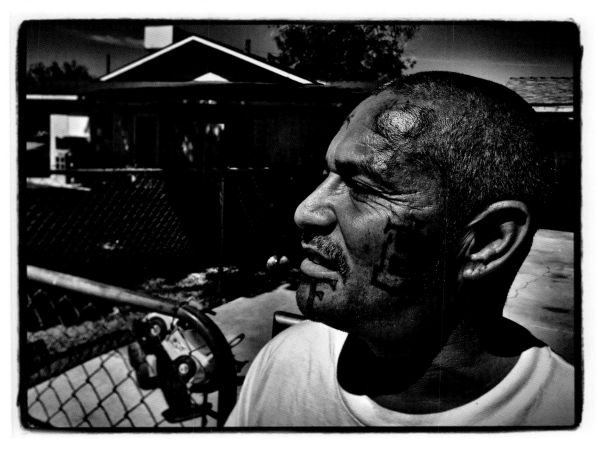

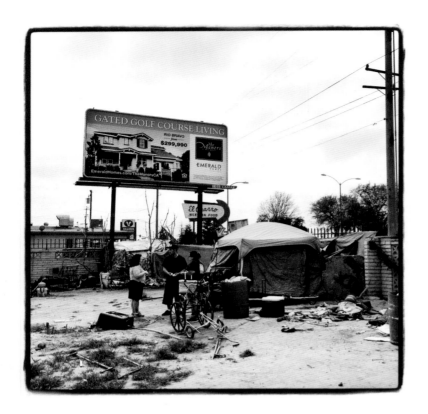

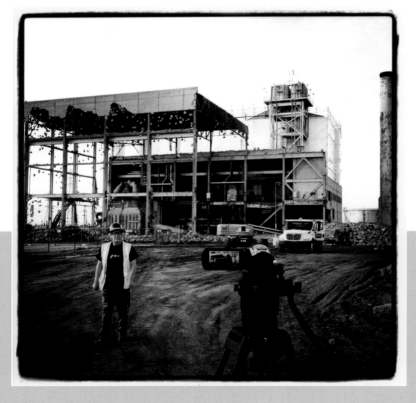

■ Study in Contrast (top left)

Most of the time, I try to keep words and signs out of my photography. Text can dominate an image; it is very powerful when combined with images (just ask advertisers). Again, though, we're talking about guidelines, not rules. In this case, the words "gated golf course living" juxtaposed with a homeless encampment is a good combination—in my opinion.

■ Power Plant (bottom left)

This is not an entire chapter on homelessness, although it could be. There are times my work takes me in other directions. In this case, it was to a power plant that was about to be partially demolished. If I remember correctly, they were going to knock down the steel frame on the left side of this image. I made this shot right before the giant cloud of dust engulfed us.

> **"There are times my work takes me in other directions."**

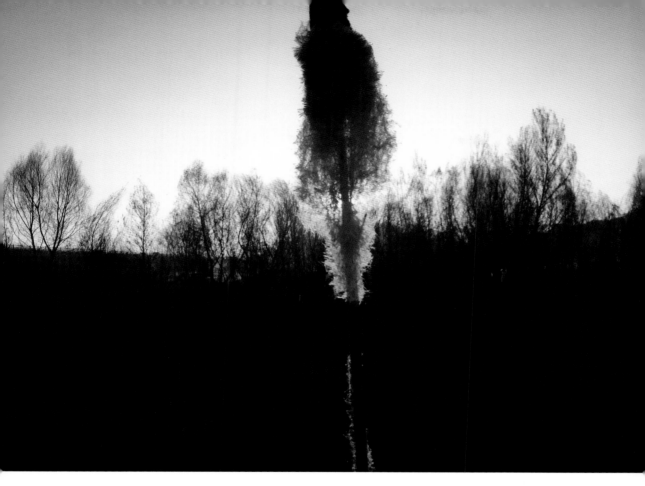

■ Lone Cattail *(above)*

While out on one of my Point in Time Counts, I spotted this lone cattail about to lose its seeds along the Kern River. As the sun started to peek up over the mountains, and the cold started to dig into our bones, there was this quiet little moment. I suspect the team was tired of waiting for me by this time and, like my family, had walked farther up the river.

■ Lavender Shoe *(right)*

I am not quite sure why this shoe caught my eye. Perhaps it was the location, on a riverbed; perhaps it was because I didn't see its partner anywhere. It also doesn't look like your typical high-heel shoe (but I must confess to not being aware of fashion trends).

There are photographers who make a habit of photographing "found" objects like this.

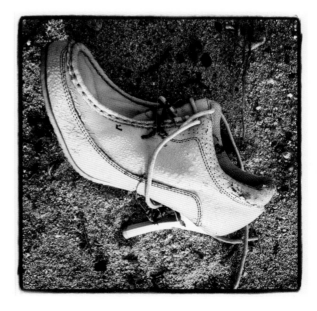

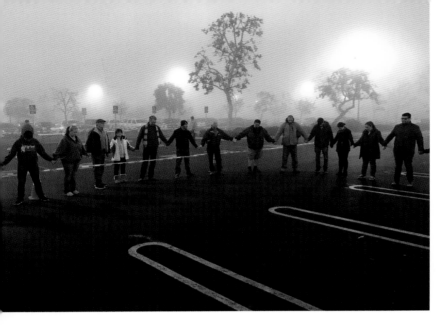

■ Love for Thanksgiving

On Thanksgiving morning, you can usually find me gathered with a bunch of volunteers at an event called Love for Thanksgiving. In the week leading up to Thursday, volunteers prep thousands of turkeys and everything else you need for a meal. Then we meet in a giant parking lot to box up and home-deliver meals to the hungry in Bakersfield.

Many of the turkeys are cooked deep-pit style—with a hundred turkeys *(below)* cooked at the same time! Add in early morning light to turkeys that have been steamed in a pit and magical and fun things start to happen. The turkeys get boxed up so that people are better able to transport the meals. I will tell you that it is some of the best tasting turkey I have ever consumed—although I think the flavor is enhanced because we feed others before ourselves.

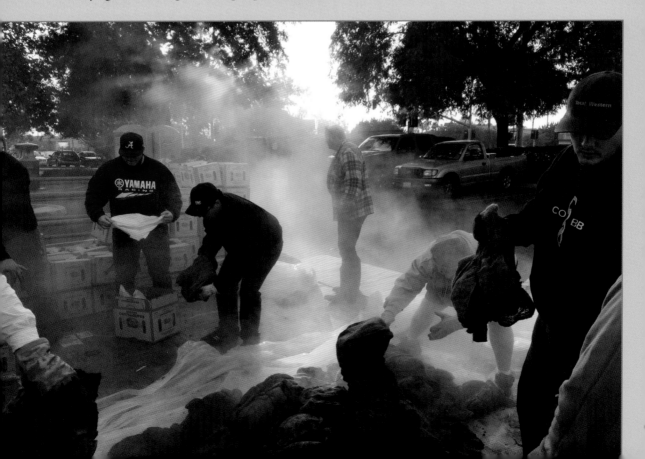

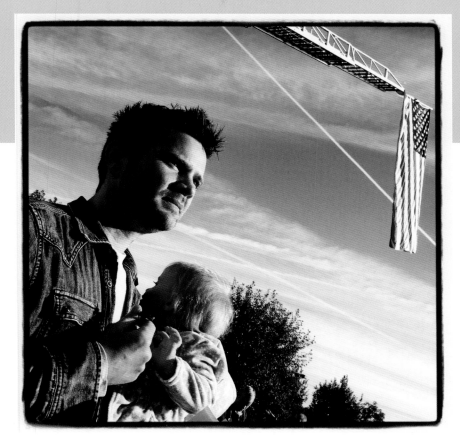

Although he denies it on a regular basis, Brandon Smith *(top right)* is the driving force behind Love for Thanksgiving. It is good to have friends who drag you into things that help your community. Although, in this case, I always point out how early he gets me out of bed on Thanksgiving Morning. I am sure that doesn't get old either.

A great thing about "Love," as we call it, is all the volunteers who show up to help out. Some wear remarkable hats *(bottom right)* as they line up to pick up meals. Considering that we helped feed over 70,000 people in 2016 with thousands of volunteers, there was very little anger or frustration among people waiting in line. In fact, I found lots of smiles.

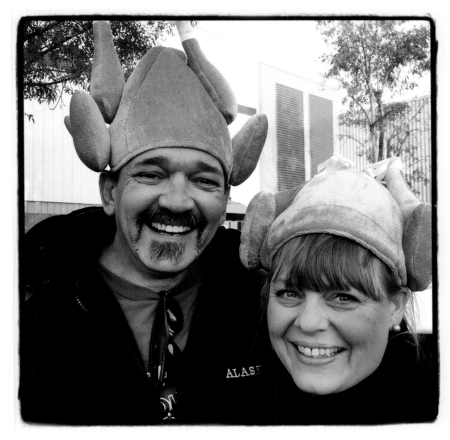

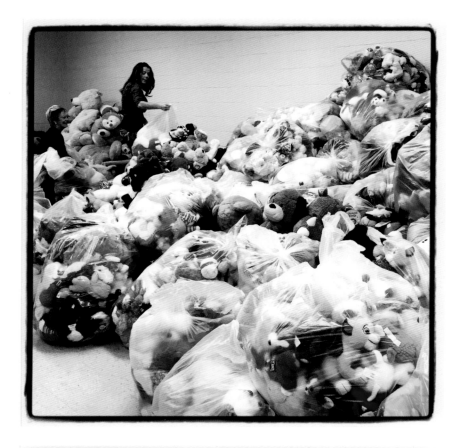

■ Bakersfield Condors

Our local minor league hockey team, the Bakersfield Condors, holds one of the biggest teddy bear tosses in the country on Thanksgiving weekend. Thousands of bears have been thrown onto the ice after the team's first score. In this image *(top left)*, a volunteer helps count and sort bears on the Monday after the event.

Every now and then you find yourself in places that not a lot of people get to go *(bottom left)*. Stage lighting (or, in this case, sports arena lighting) is intended to look really good to the audience—in this case, the fans at a minor league hockey game. Remember how I advised you to get a new perspective by turning around and looking behind you? Being "backstage" is another thing that can give you an entirely different perspective on things.

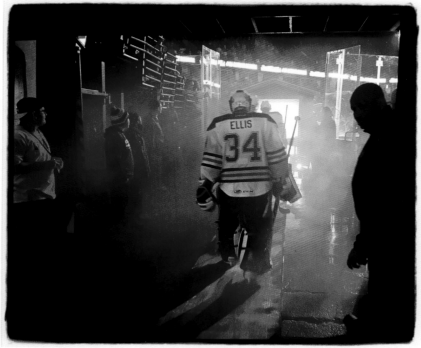

■ Media Savvy

(top right)

Even Episcopal Bishops are becoming media savvy these days—I suspect they have to. Here, the Right Reverend David Rice takes a selfie with parishioners outside St. Paul's Church in Bakersfield. I should disclose that David and I are friends—but you will find out more about that later in the book.

■ Read Across America Day

(bottom right)

Is there anything better than reading Dr. Seuss stories to children while dressed up as The Cat in the Hat? I doubt it. If you do find something better, let me know and I will show up to make photographs. Yes, I get paid to do fun things—ssshhhh, don't tell my boss!

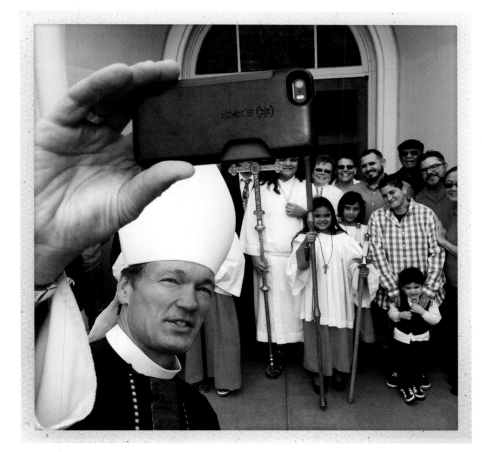

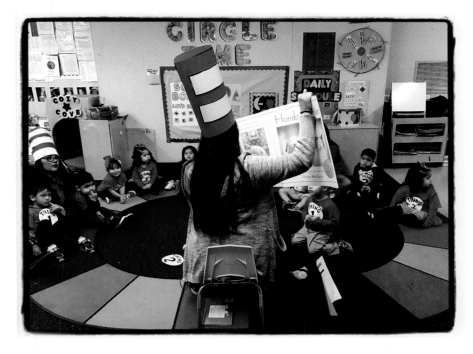

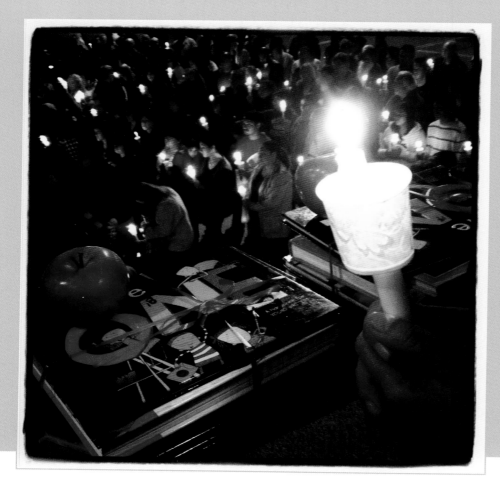

■ Vigil

This candle-light vigil for the victims and survivors of the Sandy Hook Elementary School shooting was held outside the Bakersfield City School District. An ecumenical lineup of clergy spoke to the somber assembly. Showing one candle in the foreground helped pull the viewer into this image of the crowd.

■ Volunteers (below)

Volunteers finish writing up their reports from the Point in Time Count using a giant map of Bakersfield as a reference. It is an impressive effort when you look at how many volunteers gather, disperse, survey, and then return. That is the effort needed to end homelessness.

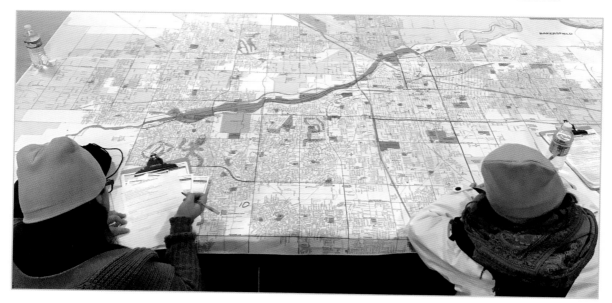

3. Food

There is great satisfaction in making things with your hands, or at least making things at home. There is an entire subculture of "makers" and, in my case, people who play with yeast. There is nothing like drinking your own beer, biting into your handcrafted pizza dough, or enjoying a home-cooked meal.

We seem to be losing this ability to do things at home. Years ago, a Food Channel star got started providing demos for customers inside a gourmet market at the same shopping mall where I helped sell outdoor sporting equipment and clothing. Even then, I could see that people had to be cajoled or shown how to prep food at home.

There is not much mystery in this process; mostly it takes time and patience (something that, yes, seems harder to find month after month, year after year, in our lives and culture). But I am glad that I make the effort and have been slowly learning from mentors, friends, and recipes.

I really think more of us need to reclaim this in our own lives, making something by hand—whatever it might be. My wife argues that brewing and making pizza are ways for me to get my mind off of whatever might be going on in my life. Some folks can find this escape in dishwashing or lawn mowing, but not me. There is some satisfaction in seeing things done, but I like the "value added" of feeding bellies as I feed my soul.

> "There is great satisfaction in making things with your hands."

■ Pizza Club

I started making pizza because I could not find good New York–style pizza in our home town in California. Nothing seemed to meet the standards of a good NYC pie. I wanted a good, thin crust with lots of taste and the architectural ability to hold cheese and toppings and not fold over or lose shape. In short, I wanted what I grew up with and missed.

Over the years, this pursuit of home-baked pizza has led me to try many different techniques (including grilling) and recipes. The pizza dough I have settled in is a 48-hour affair based on a sourdough starter and takes little hands-on work. It is primarily successful because of the passage of time and the amazing impact of the yeast. (I am now moving into making kimchi at home as well, so fermentation may be taking hold as a sub-theme in my life!)

All of this experimentation also led to the start of what we now refer to as "pizza club." (And, yes, the first rule of pizza club is to tell others about pizza club.) Every few months or so, I will wake up the sourdough, get it going again, and then let friends know that I am going to "throw pies." What follows is an evening of conversation, laughter, and pizza—lots of pizza with lots of different toppings, each placed on the table with salad, fruit, and wines. It has become an evening of much more than just food or friendship. When we hit our stride, I am putting out a fresh pizza, with very small slices, just as the last pie is disappearing. Some rookies eat too much too early in the evening and miss the different pies that follow. Sometimes, the toppings are what I have on hand; other times, they are moments of inspiration, creativity, or (according to one of my brothers) pizza blasphemy.

We just call it pizza club.

"In short, I wanted what I grew up with and missed."

■ Mocha Still Life

I take a lot of photographs of cups of coffee, mochas to be exact—probably because I drink a fair number of them, truth be told. A new place opened up in town and a metal table top, mocha in a glass, and a small cookie on a spoon created a beautiful (and delicious) still life.

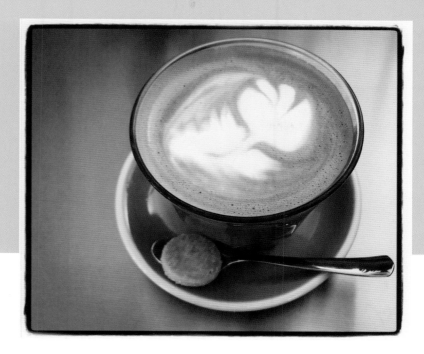

■ Morning Light (below)

There is nothing like morning light streaming into a coffee shop to help a drink go down smoothly. My brother has found this great place in his home town—and the artistry with the foam, the blue cup, and the rich dark browns from the beverage are all working together in this image.

■ Lighting on Glass

Glass has a very interesting characteristic when it comes to lighting. You can either capture black lines or white lines on glass; it all depends on the background and lighting. In this particular situation *(top left)*, candlelight on a table highlighted the water level and condensation on the glass.

This Belgian Tripel Ale is home brewed *(bottom left)*. Shooting from beneath the glass with strong side lighting from the sun and a clear blue sky all worked together for an abstract drinking image. I love how clearly the bubbles stand out and how the shadow of the text falls on the surface of the beverage.

■ Waffle with Side Light (above)

I wore my wife down and finally we own a waffle maker. Here is a fresh Belgian yeasted waffle with a healthy covering of sausage gravy for a savory breakfast or dinner meal at our house. My mouth is watering just looking at this. Side light, in the early morning or evening, is a great, low-budget way to make strong food images.

■ Side-Light Still Life

Uncle, uncle! We get it—side lighting and shadows! Even though this is not a photograph of food, I made it in a lovely little bakery in our city called De Coeur (meaning "from the heart") Bake Shop. The owner is a friend of mine and a true artisan when it comes to French pastries. This floral arrangement and shadow caught my eye and pulled me away from the conversation I was having.

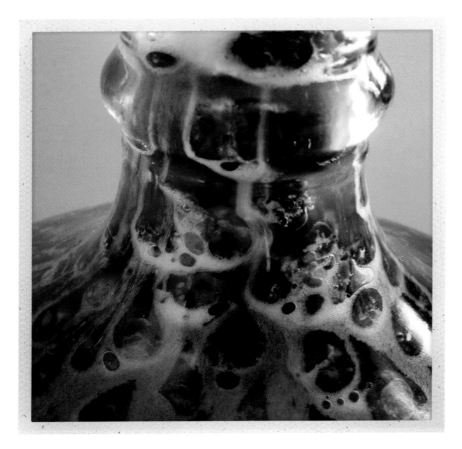

■ Mead (top left)

Mead is the proper name for a fermented beverage made from honey, water, and yeast. It becomes a melomel when you add fruit (here, blueberries). I love the carbon dioxide working its way up past the fruit, the color from the berries, and the smooth shape of the glass carboy holding all of the delicious goodness as it slowly becomes something drinkable.

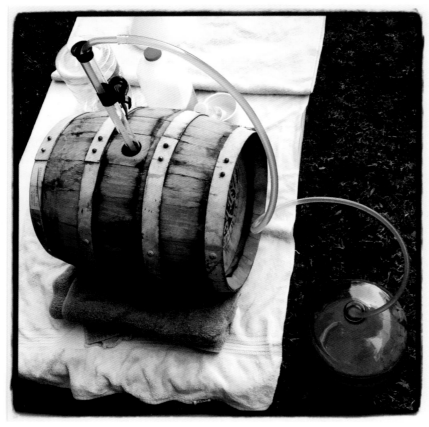

■ Oak Cask (bottom left)

If you want to take your home brewing to the next level, a whiskey-cured oak cask could be the way. Here, cider is moved back to a glass carboy after fermenting "on oak" for about five days. The trick is to compliment the cider with the taste from the barrel while keeping some of the floral notes from the apples. The image, you ask? The gentle spiral of the tubing works to move our eye through the photo, of course.

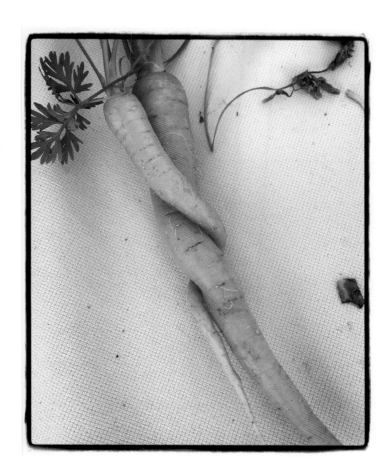

■ The Lovers (left)

Carrots like this are called "the lovers" because they wrap themselves together. As a waggish friend of mine observed, they are also delicious with hummus. I'm not sure what that says about either one of us; I will let you draw your own conclusions. The white tents used at farmers' markets make for great softboxes; they diffuse the light and allow you to get soft, even lighting in situations like this.

■ Two Mind-Sets

The start of brewing means foam, glass carboys, and patience. When I was reading politics at the University of Aberdeen in Scotland, we were never patient enough for brew bags to fully mature. We would be tasting them a week in—we were young and impatient. Time is on my side with brewing, but not so much with photography. As I mature in working with yeasts, I need to learn to be patient; in photography, I have found that I have to be present in the here and now. Sometimes it is hard to move between the two mind-sets, but each informs my work in the other area.

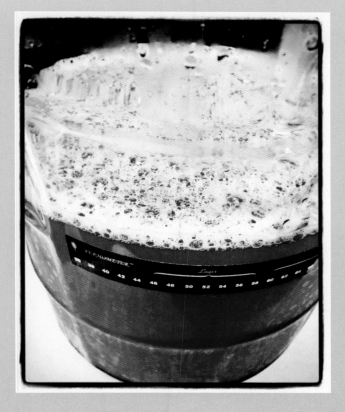

4. Family

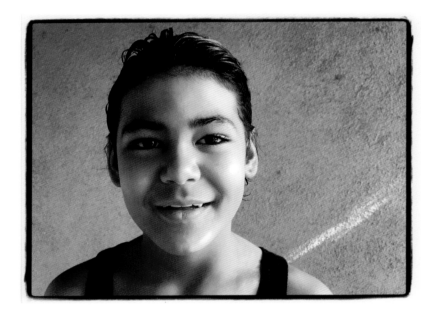

"Growing into the role of Dad has been good for me."

■ Parenthood

My wife and I agreed to no conversations about children for the first year of our marriage. We thought that it would be helpful as we worked on our own union. Little did we know how things would change.

To make a long story short, one day we found ourselves waiting in an airport for what turned out to be a very energetic five-year-old girl. Our lives have never been the same and growing into the role of Dad has been good for me.

Fostering to adopt was not our original plan, but it has suited us as I continue to work against human trafficking. Some of the children most vulnerable to human traffickers are those in the foster and adoption system. Children who are desperate for attention, and potentially mistreated or abused, are looking for *anyone* to love them. This is a hard truth in the world we inhabit.

All the challenges aside, even on our worst day it has always been worth our time and love. Even now, as I type, I can hear her humming and singing away in her room, sometimes melodically.

Children are remarkably resilient and bounce back from trauma that I cannot ever imagine experiencing. The need to be loved, to be cuddled, to be encouraged, supported, and introduced to new things is what it means to be alive and a human being.

Being part of helping someone grow into an amazing person is truly humbling. Most of the time, I am just worried I am going to screw something up. The person I have come to love is an amazingly strong, loving, funny, athletic, caring, and bright young lady.

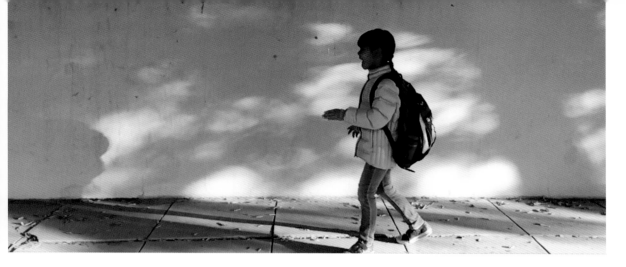

Initially, we weren't sure how long she would be in our lives, and after five months she moved back to live with her great-grandmother. We kept in touch with monthly phone calls and tried to keep in mind that we had, at least, shown her a home that she could choose for herself later in life.

That all changed when Palm Sunday and Easter phone calls brought our special young lady back into our lives! In 2015, when my first book was going to print, we had not yet finalized her adoption and I was unable to include any recognizable images of her (you can still see her in a few if you look carefully).

■ Take Nothing for Granted

Too often, we take for granted those we live with. What I have come to discover is a partner in photography, exploration, and fun. I am sure, like most photographers' family members, she will eventually grow tired of the camera pointed in her direction. Until then, I am going to make the most of things. I have also come to learn that I was well prepared for the role of a lifetime, although (like all of us) I fall short on a regular basis.

Just like any child, she can be trying, amazing, frustrating, beautiful, funny, sad, and honest. I am always surprised at the sto-

ries I am told and the conversations we have. The opportunity to see the world through her eyes sometimes helps my photography.

We also hold her during the times she mourns the life she was ripped from and the biological mother she misses. All you can do at a time like that is hug her and let her know that she is loved. We tell her that it is our job to help that wound scab over and, with time, become healthy scar tissue. That wound will never fully disappear. We are so happy to have her in our lives, but we also try to help her deal with the world that brought her to us.

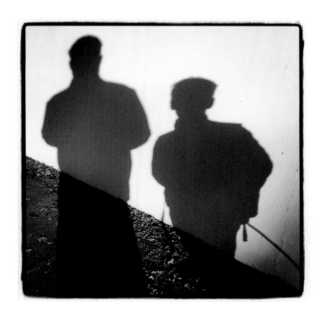

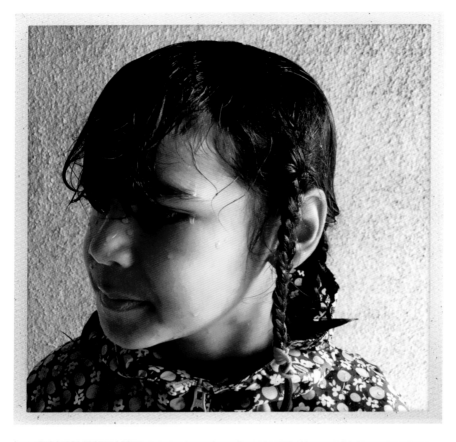

◼ Raindrops (top left)

I love this image because of the raindrops on her face. Usually, you want to give the person space to look into at the edge of the frame, so this image bends one photo guideline. I am okay with that. The light for this image (the sky) is from our right. If you look at the background, you can see how fast the light dropped off from the right to the left.

◼ Body Language (bottom left)

Keep an eye open for body language. I love how she has her hands on her hips, looking up our street and contemplating what to do next. The color from her rain jacket and striped boots stands out from the grayness of the street and wet sidewalk.

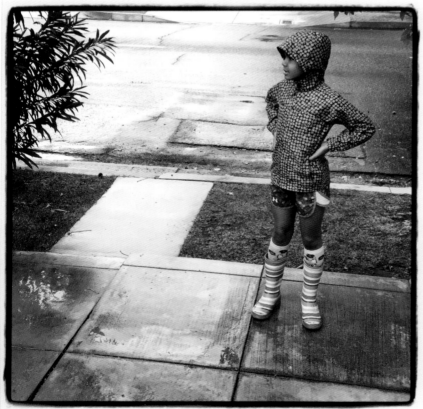

❝I love how she has her hands on her hips . . .❞

■ Spinning (right)

This is probably the image that got me in the most hot water as a Dad and photographer. As we took family pictures before church, someone discovered what twirling around would do in her dress. Dad, the photographer, says, "Cool, do that again." And the look on her face says it all. Of course, one or two spins later she slipped and got the back of her dress a little dirty. But the light was there, the time to make pictures was right, and we have a lovely record of that morning.

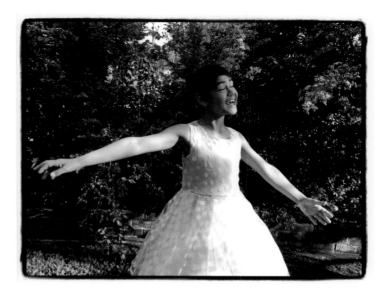

■ Courage (below)

Parents always walk a fine line between healthy encouragement and pushing too hard. After an hour of sitting on the tree, getting off the tree, and watching others have fun, she finally gathered enough courage to swing into the Kern River. The rest, as they say, is history. We could barely drag her away from the river at the end of that day!

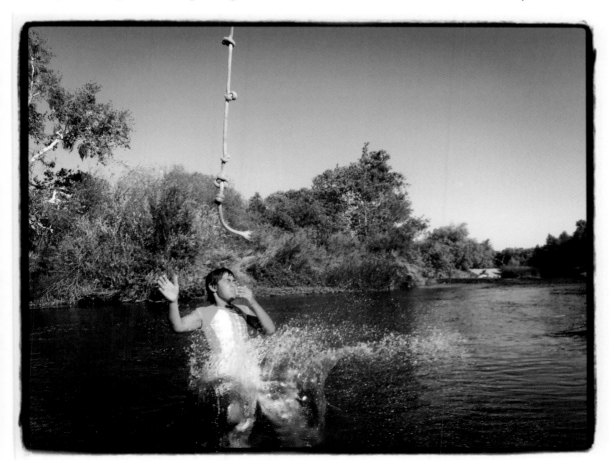

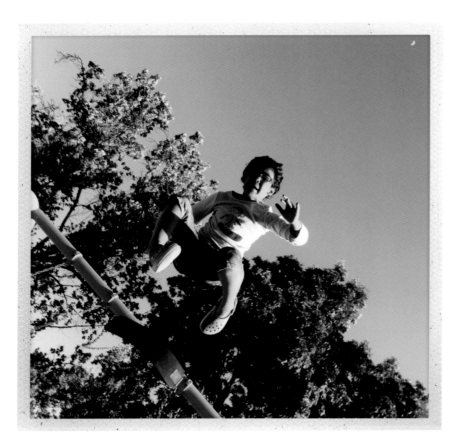

■ Take Some Risks (left)

There are times a little fear is healthy—and then there are the silly things you do, like jump off swings . . . and have an adult in your life who is crazy enough to kneel on the ground near your landing pad. Have fun and take some risks with your photography in a responsible manner. Do those two things sometimes oppose each other? You bet. Welcome to life.

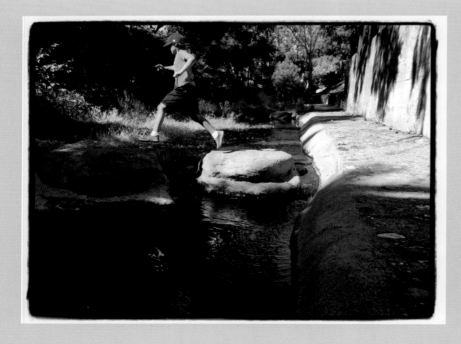

■ Shutter Lag

One of my major headaches with the iPhone (compared to my professional gear) is the delay between when I press the button and when the camera captures the moment. Sometimes I still miss the shot—but with patience and persistence, I have been able to get a better feel for when to press the screen.

■ Ususul Locations (above)

In San Louis Obispo, there is a weird little alleyway where people deposit their gum. Apparently, Seattle has a similar passageway. Here, our daughter looks very closely at the piece of gum she added to this public art installation. I like the strong graphic lines and symmetry of the image, as well as the fact that having her looking to the right of the frame throws off the symmetry.

■ Meaningful Moments (right)

In our home, we happily blend the holi-days—so a menorah and a Christmas tree fit together and make perfect sense. Here, Grandma (my mother) offers some guid-ance on the correct way to use the *shamash* to light the other candle on the menorah. As with all things religious and codified, there

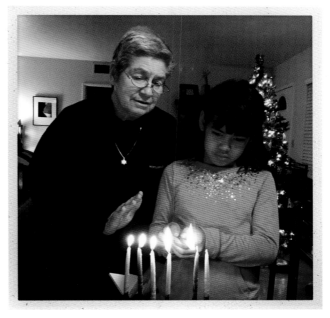

are proper forms to be observed and for good reasons. I am very appreciative of ceremonies that turn our home into a sacred space.

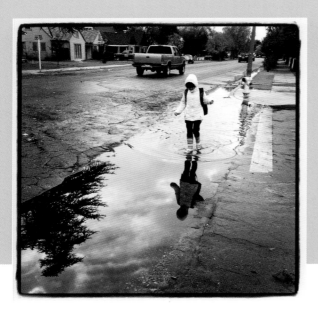

■ A Shared Human Experience

The reflection, strong diagonal, and spot color of the truck are all working together in this image. What really helps this photograph is that it shows an experience almost all of us have had—walking through puddles, wishing we could walk through puddles, or (even better) jump and splash in puddles. Those moments that speak to these basic human desires and experiences have a subtle yet strong power to speak in our lives.

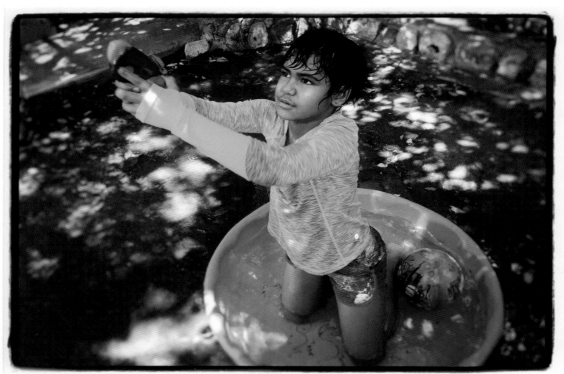

■ Imagination *(above)*

What's going on here? Someone really likes to play in the backyard—beyond that, your guess is as good as mine. The intense look on her face, the dappled light in the background, and the long sleeves of her rash guard are all working well in this photograph. Processing this image in the Snapseed app added some vignetting and blurring around the edges of the frame.

■ Tire Swing (top right)

Is there anything more Americana than the constitutionally required swing in your yard? To create this image, I used Google's Snapseed App to tone and vignette the edges of the frame and add a border. It is hard to beat the power of this app on your phone—especially when you take into account the low cost (it's free!).

■ Heading Home
(bottom right)

There is nothing like the relief, anticipation, and tiredness you feel as you head back to the car after an afternoon of fun and bumps sledding and playing in the snow. It can be a cold walk—unless you have someone to hold onto and discuss the fun things that happened. It's a pleasure to recall the spills and the snow down the neck of your jacket— and, of course, to discuss when the hot chocolate can be consumed. It is the simple things in life.

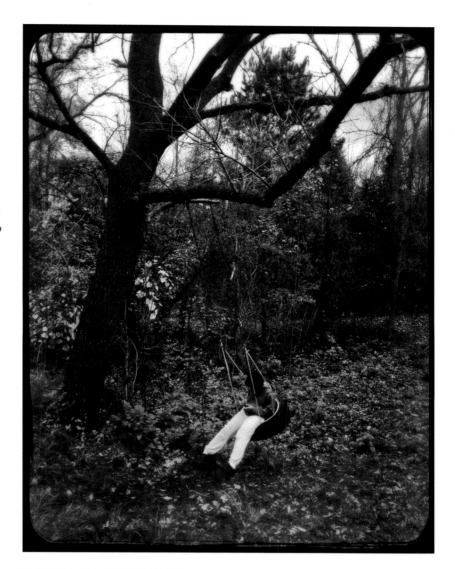

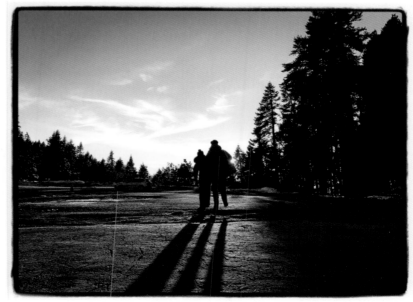

5. If You Build It, We Will Photograph It

■ An Appreciation for Architecture

When I was in high school, my parents thought I would become an architect. We even went so far as to take a tour of the New Jersey Institute of Technology's program. That is one of those paths in life I did not explore fully. When I was at the Rochester Institute of Technology, one of my friends was a former architecture student who had dropped out because he saw there would be few opportunities to build his dream structures. I am not saying that was enough to reassure me that I had chosen wisely, but I did feel much better about the path I had been following. Still, I enjoyed my architectural photography class and I certainly continue to enjoy photographing buildings and exploring how light interacts with their design.

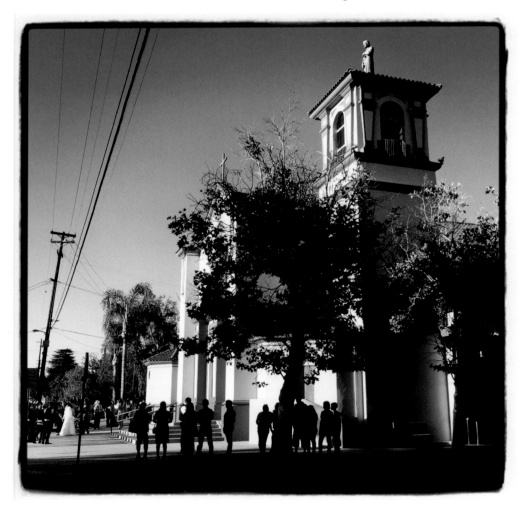

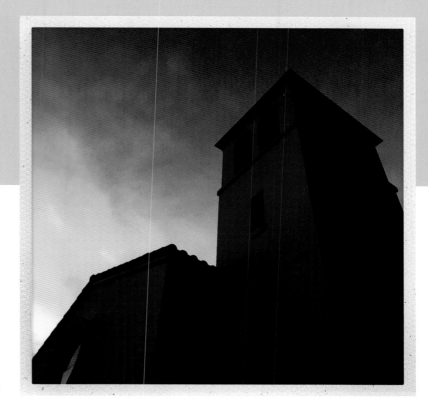

■ Late-Day Light (top right)

I like this image because of the clean lines from the church's bell tower. The pastels from the clouds in the setting sun and evening sky add a pleasing complement. The glow of the sunlight on the walls of the building offers a nice contrast and the darkly shaded areas of the building add depth to the image.

■ Texture, Lines, and Color (bottom right)

This the rear of a landmark building in Bakersfield. The way the weather patterning flows down the wall reminds me of the cliff dwellings in Arizona, New Mexico, and Colorado. Add in the graphic lines from the power and telephone cables and blue sky and fun things happen. I was asked to make an image in one day as part of an interview with a magazine about my first book, and this is what I sent them.

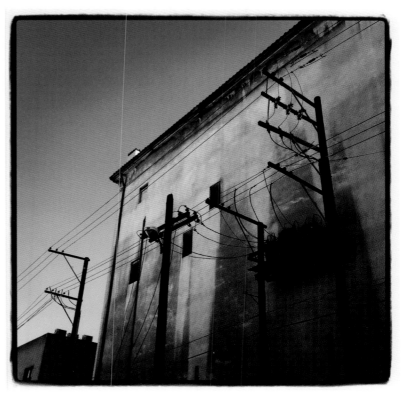

■ Try, Try Again (above, left and right)

There is nothing more frustrating than seeing something and knowing that there is a picture to be made—and yet not quite being able to get it (see chapter 9). Part of my problem here was that I needed to get inside and interview someone in the building behind me. Feeling rushed is not the best cat- alyst for trying to explore something like this visually. Often, I will walk along, mostly just using my eyes and then holding up my phone or camera every now and then. I am sure it is an odd dance to anyone looking out of their office window during work hours.

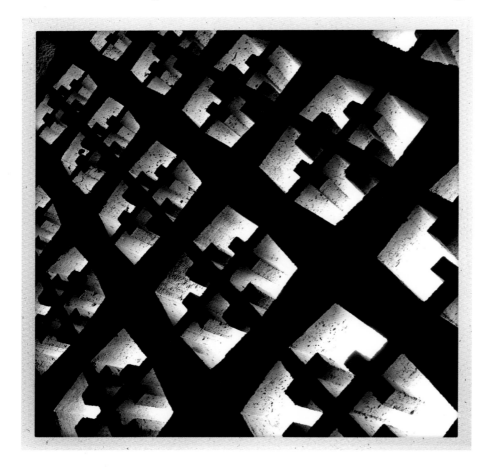

■ Repetition (left)

Repeat after me: repeating lines and patterns are your friends. I am thankful for the detail near the edges of the concrete screen to help break up the black-and-white nature of this image. This is a feature I see nearly every day and yet it took time to figure out how to photograph it well. I suspect there are times that we over-think things rather than just doing the work.

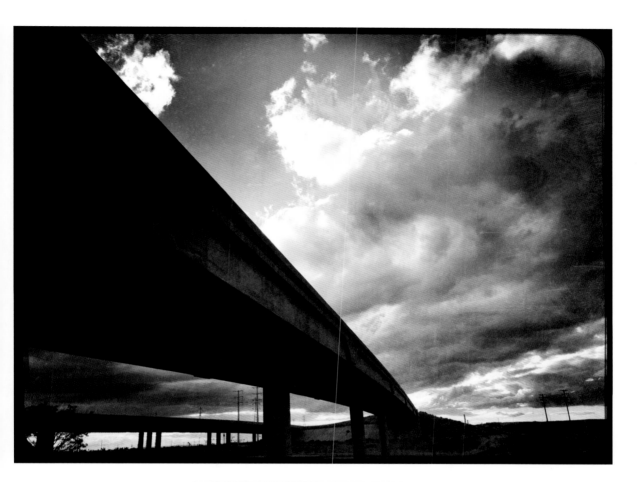

■ Concrete Bridges

(above and right)

These new concrete bridges span the mighty Kern River in Bakersfield. They are part of some much needed infrastructure improvements around town. They run over the bike trail, so I see them on a regular basis. I keep "working" on making interesting images with them. There are times

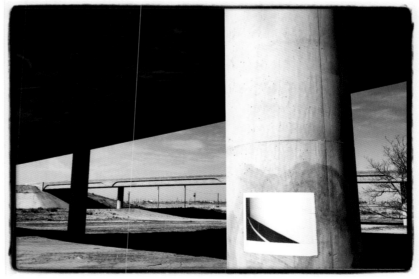

when the sky cooperates or a wandering artist pastes something up on a concrete pillar. I suspect that I am not finished here yet. We will have to see what tomorrow brings.

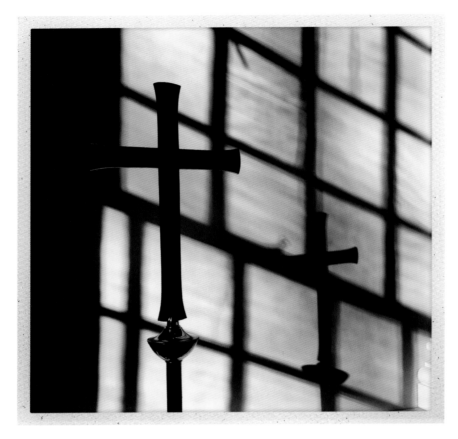

■ Symbolism (top left)

When my wife's mother got remarried, we bundled the family off to western Michigan for the event. There was lovely winter light in the chapel and the grid pattern and symbolism were hard to pass up for an image. It was a quiet ceremony, but when the dancing started at the reception later—look out!

■ Details (bottom left)

Architectural details are also worth our time; they can be interesting and even whimsical. This bathroom sported a colorful wall planter with a succulent—amidst all the other things you might expect to find in such a space. It was a nice surprise to find this amidst the hustle and bustle of an airport. Look for those little moments; they go a long way toward helping keep balance in your life.

6. Far Afield

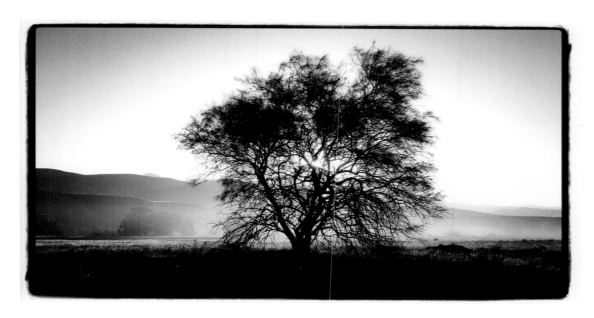

■ Seeking New Holy Ground

I shot this image while out early in the morning in a city park where the mighty Kern River leaves the canyon mouth of the Southern Sierras and enters the San Joaquin Valley. The mist you see rising up is from the warmer river water as it hits the cooler air of the valley. Add a single tree with backlighting and something magical starts to happen.

To me, the scene recalled the story of Moses and the burning bush that was not consumed by the fire dancing along its branches. I'm not suggesting that this is what he saw that fateful day, but I do think we need to act appropriately when approaching holy ground.

I walked far across the open field to get into position. I think that it was proper I did not drive—that I had to do the physical work to get there. So much in our lives is handed to us. Too much can be driven through; too many businesses and even religions cater to the "me."

So go out and discover your own holy ground. Encounter nature and fully appreciate it. One of my early mentors in photography told me that there are times we should just put the camera down and appreciate what is before us and engrave that memory into our mind.

This morning was a day not just to experience the natural beauty of the world but also to make an interesting image. There's a photography guideline about not taking pictures into the sun, but this is a good time to bend it. Like Icarus, there are times we must fly that fine line between too close to the sun and right into the magical space that produces remarkable images.

■ An Excuse to Wander

In Bakersfield, we can escape the valley and get up into the foothills and mountains, where interesting sights begin to appear. Green grass is not something we see much of outside January–March, depending on how much rainfall we get. Yes, you can see lawns year-round in the city in front of people's houses, but that is an entirely different essay for a different book.

So my family and I go for hikes, bicycle, and walk in spaces that we can enjoy in the finite time that the green is there to be experienced. What is interesting to me is that some of the scenery I see reminds me of places like New Zealand—yet I don't have to leave my town. I just need to go to the right places at the right time of year.

One of the running jokes in Bakersfield is that we are two hours from everywhere. I suspect that some implied, but never spoken, "fun" hangs over that self-deprecating joke. There are places and times of year that neat things happen . . . we just have to go a little further afield than other people. But we can get there.

For example, the Wind Wolves Preserve (southwest of town) has some great scenery, wildlife, and wildflowers, depending on the season. Yet people don't take the time to get there. I think our lives have gotten too busy to take some time to slow down and experience things—much to our loss.

My camera is an excuse for me to wander, an excuse to examine things in detail or look at the big picture. I suspect I would still do this even if I weren't a photographer, I just wouldn't have such a great looking "journal." Remember: that camera or phone in your hand is your passport to explore the world. Don't forget to collect a few stamps after you have left the threshold of your home.

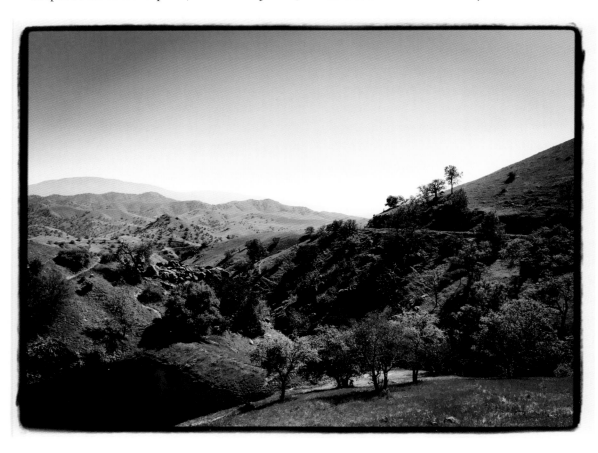

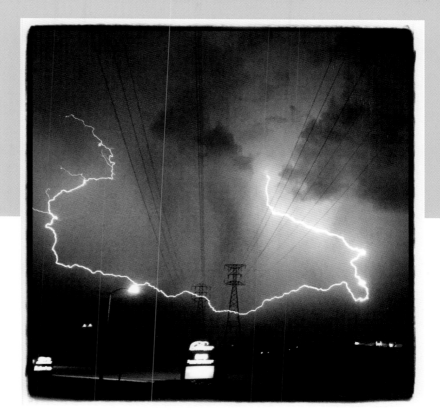

■ Lightning *(top right)*

Don't be like Mike. This may have been one of the stupidest things I have done while holding a camera—and that is really saying something. Apparently, this is a fairly normal occurrence around power lines. Guess where I am standing? An amazing lighting storm was rolling through town and I went out and took some chances with the lighting and the relatively slow shutter on my iPhone. Persistence and luck can pay off—but this shot wasn't worth the risk.

■ Fall Colors *(bottom right)*

Aside from lightning, the physical patterns that exist in life are worth our time and attention. We don't get a lot of fall colors in our part of California, but these leaves, lit by a warm setting sun, really came alive in our backyard.

■ Wildflowers

We have a very narrow window for photographing wildflowers in California. The challenge is whether to show detail, or the overall scene, or (in this case) both. Filling the frame with a few flowers *(top left)* gives us the ability to enjoy the poppy. These flowers are so small and delicate that there is really no way to fill the frame *and* show the expanse of the field *(bottom left)* in one shot. It has to be two different images. (If you manage to get it in one frame, you should be writing your own wildflower photography book!) Keeping that pesky horizon near the top one-third line was key to making the effective composition in the bottom image.

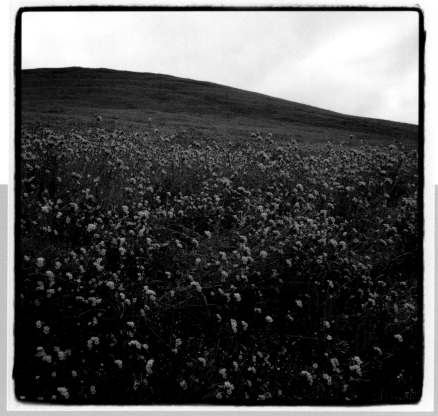

> **"The challenge is whether to show detail or the overall scene."**

■ Farmer's Market

Cut flowers can no longer be purchased at California farmer's markets—at least not in the San Joaquin Valley. I can't explain the decision, nor do I have the room to try. However, this is a good example of filling the frame, especially when it is all the same stuff and the same hue. There is also more layering here than you might realize at first.

■ Blue Agave (right)

In this image of blue agave, we have repeating shapes and alternating layers of light and dark. This was made in the parking lot of a business—you just have to keep your eyes open for good subjects. Being a minute or two late to a meeting but with a fun image in-hand is not a bad way to live life. You can even own it and get the person talking about a plant they may or may not have really looked at before. Or, be crazy and get places early; give yourself the time to find some serendipity!

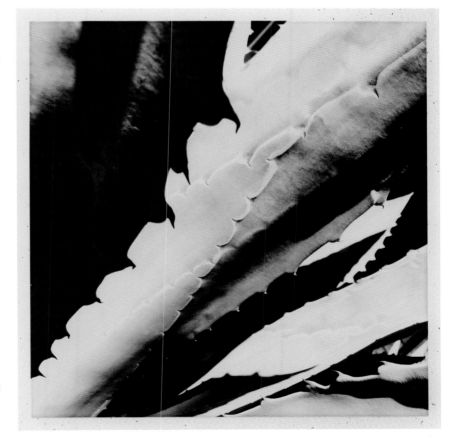

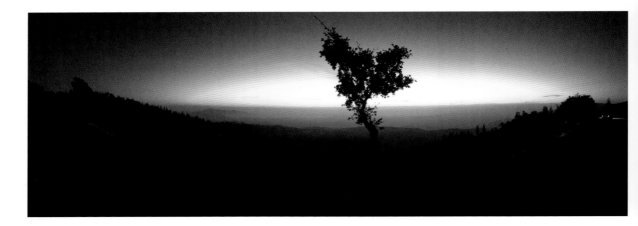

■ Context and Composition

Context and composition matter. We can call this a tale of two trees (but I am sure you have already spotted that this is really one tree, with a different feel in each image).

There is a very isometric feel to images when you use the panoramic function *(above)*, especially in a place like this where the road bends. There is also a decidedly different feel to the skies in the two images.

Every now and then, when I was working as a photojournalist, we would send out an e-mail with two similar frames and get people's opinions on which they liked better. Sometimes, like in this case, I don't think there is a right or wrong answer.

■ A Fractal Flavor

If you do any reading about fractals and how often they occur in nature, the two images on this page make a lot more sense. One is a macro version *(right)* while the other a much larger view *(below)*. A true fractal repeats in the same pattern at every scale, but branching in the growth patterns of plants and trees are also interesting.

This tree is on the grounds of La Paz, the final resting place of César E. Chávez, labor leader, civil rights activist, and co-founder of the National Farm Workers Association. I brought this image into the Snapseed App to work on it a bit, something I rarely do on most of my work (other than to tweak the saturation and add borders). Here, a little softening of the focus on the left and the right helped my eye stay in the frame and work its way up to the top of the tree.

■ Waves (above)

To paraphrase Carl Jung, some-
times a lake is just an image of a
lake; let's leave cigars out of this.
What caught my eye on this day
was the waves, drummed up by the
relentless wind near Ebbetts Pass.

■ Experience the Moment (left)

Likwise, sometimes a sunset is just
that—a wonderful play of light,
clouds, physics, and silhouettes.
Go out some night, take a picture
of the sunset, and then listen to
some advice from my mentor Dave:
put the camera down. You might
surprise yourself with what you
discover.

Yosemite Valley (right)

Yosemite Valley is worth everyone's time to visit and (if you have a strong stomach) photograph. So many iconic images have been made there that you almost have to fight off a sense of impending doom or frustration. I say that mostly tongue in cheek, however there is some truth to it.

Bridal Veil Falls (below)

It is a bit of a walk into Bridal Veil Falls and a serious hike up to this section of the falls. Yes, I carried up my 35mm camera and tripod plus my phone. Part of the fun of shooting with my phone is that the limitations of the sensor push me to frame shots I might not normally make or compositions that are outside my usual style. That is one reason I appreciate and keep using my iPhone.

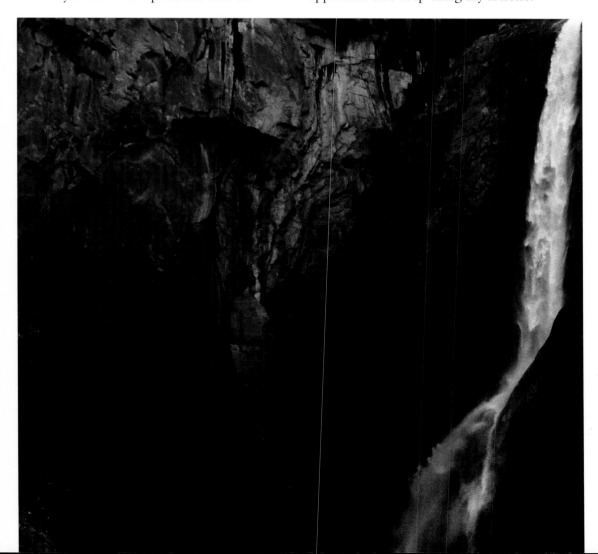

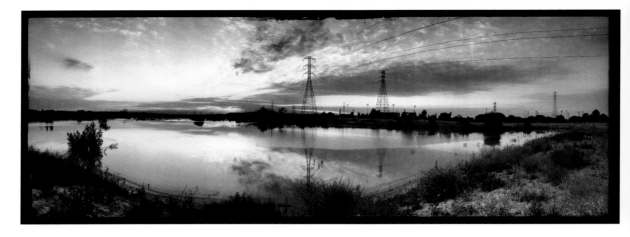

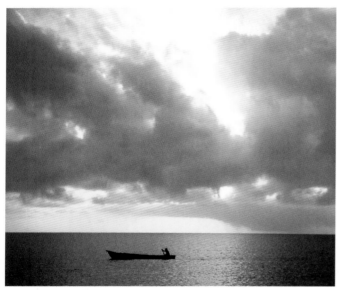

■ Water (above)

Bakersfield can be quite beautiful in the early morning. No, the power lines are not curved like this; that is an artifact of the iPhone's panorama setting. We don't always have water in the river-bed—but that's a long story about water rights, human beings, a semi-arid region of the country, drought, agri-culture, and oil production. It would probably be easier to watch the movie *Chinatown*.

■ Seeking Beauty (left, top and bottom)

No matter where you live in the world there is beauty—find it. Yes, this boat is in Belize, but something similar (minus the boat, perhaps) could be in your backyard. Have you gotten up before sunrise yet? Is there a body of water nearby or will you have to drive?

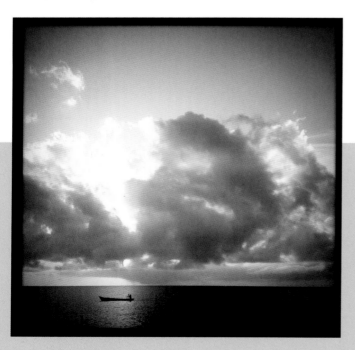

> **"No matter where you live in the world there is beauty – find it."**

■ Above the Clouds (right)

Here, yes, you will need an airplane to get the shot. I travel much less these days, because we have two young ones at home and I enjoy watching them grow up and discover things. In this case, though, we were all in the row together—and the play between the clouds, Lake Michigan, and the sun was too intriguing to ignore. I much prefer a jet plane to single prop airplanes for making images (or at least my stomach prefers the jet).

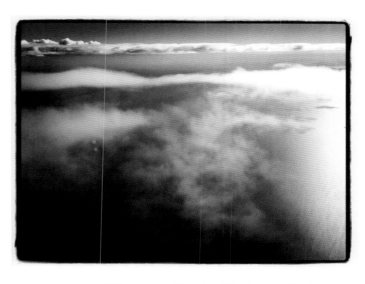

■ Chicago from the Air (below)

This image was created on the same trip. Chicago sits in the background and I got a great view of Montrose Beach with the marina in the foreground. Without the hook of the marina and the highlights on the water, it would not have been as interesting an image.

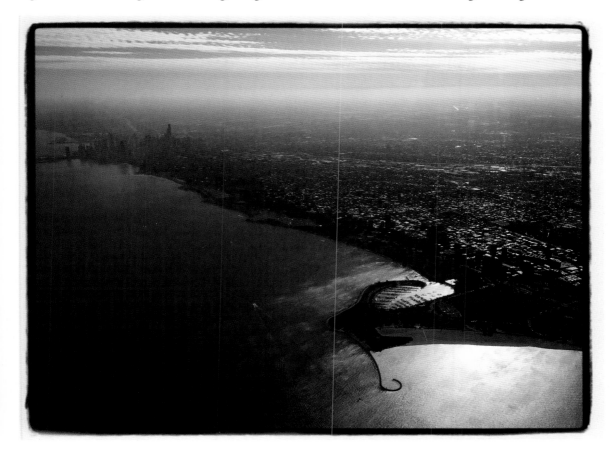

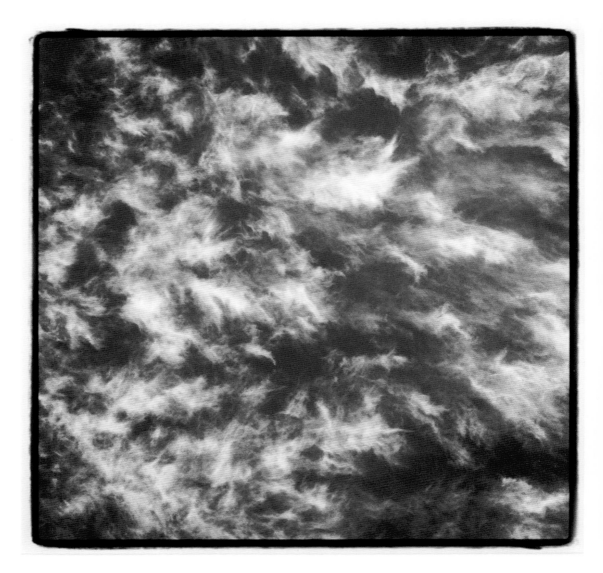

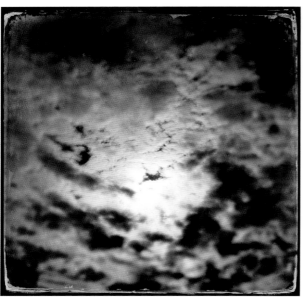

■ Clouds

Can you photograph cotton candy in the sky? I just walked out the door, looked up, and there it was. Writing this guilted me into looking up what kind of clouds they are: cirrocumulus *(above)* and altocumulus or stratocumulus *(left)*. We don't often see cirrocumulus clouds in my part of the world. They form 20,000–25,000 feet up. (Now Bill Nye can check a box for "teaching photographers to do a little basic research"!)

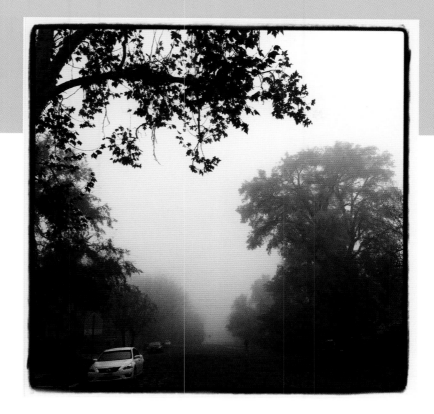

■ The Mist (top right)

Okay, okay, Mike—we give. Why all the clouds, fog, and mist? For reals? Because they all obscure the land, the city, and your view, letting our minds imagine what could be happening just out of view. What could loom out of the fog next? Adding the tree as a framing device really helps make this work, as does the white car.

■ Look It Up (bottom right)

I had to look up something else: these are called anticrepuscular rays. (Didn't think I could find that term, did you?) Crepuscular rays appear to come down from the sky so, you guessed it, anticrepuscular rays stream upward like these. This is way too much physics, don't you think? Just go out and make some interesting pictures, gang. You can look up the terms when you get home.

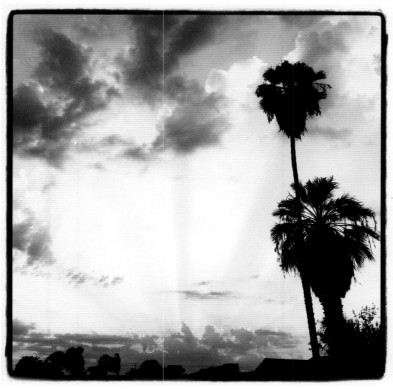

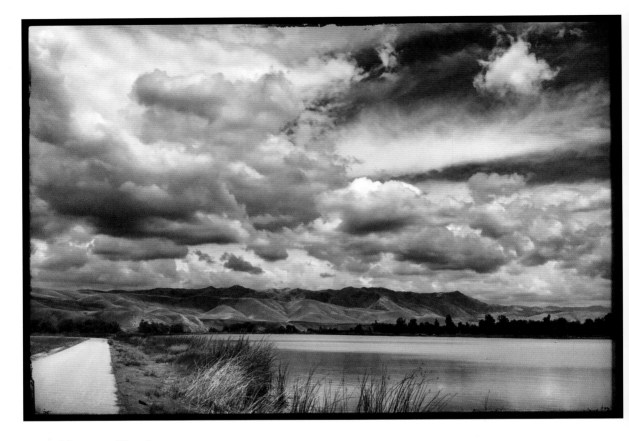

■ More on Clouds (above)

We have a couple pages of clouds left. Apparently I have a previously undiagnosed fetish for photographing them. I suspect it is just that I try to maintain my childlike wonder about the world. Note that I said "childlike" not "childish." There *is* a difference (although my wife will probably disagree that I can easily discern between the two).

■ Transform the Familiar (left)

I am fortunate to live in a beautiful part of the world—but so are you. If you don't think so, you may just have to work a little harder.

I showed some of these images to a photography class at a local high school and they couldn't believe that we live in the same city. Go surprise your friends.

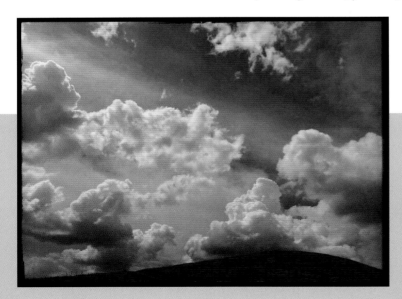

❝I try to maintain my childlike wonder about the world.❞

■ Stillness and Repetition

Some photos just evoke a mood for me—it could be the same feelings I was experiencing while making the image or something the scene makes me think of when I look back.

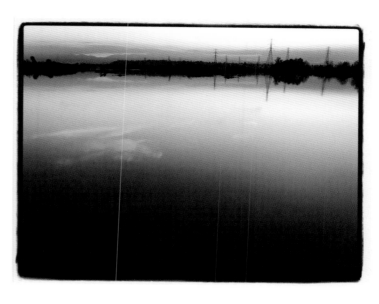

The image to the right was made early on a quiet morning, when the water was fairly still. In the image below, observe how the repetition of shapes in the palm trees helps the clouds out quite a bit. What moods do these images inspire in you?

And, yes, this is the last page of clouds—although we may see a few more shots with clouds in them when we get to chapter 10. I guess we will find out together!

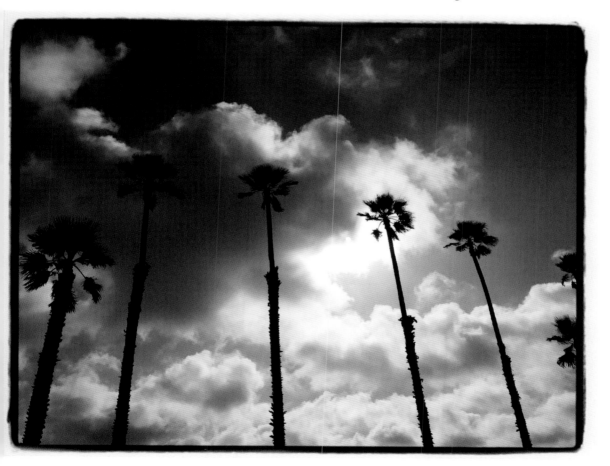

■ A Lovely Breeze (right)

Get out there into nature and start making images! There was a lovely breeze blowing these grasses, and the only way to capture an interesting photograph was to be right there, wandering at the edge of the field. One warning: please, please, please do not walk out into farmers' fields and damage crops. Use your common sense.

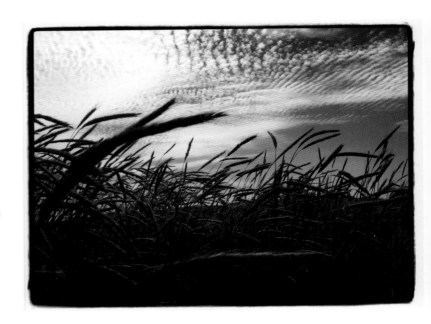

■ Composition and Focus (below)

Getting great images comes down to editing throughtfully within the frame of your camera or phone while you shoot. Think about perspective, composition, and how best to utilize your depth of field (how much of the scene is in focus). At the end of the day, it still matters what you include and exclude. Editing in the camera makes editing at home *much* easier.

7. Selfies and Portraits

■ A Whole Lot of Fun (right)

Most of us take selfies—so do we really need an essay to open our look at what may be the most fun thing to do with your iPhone? With family and friends, I have been known to have *way* too much fun in situations like this.

■ Get in the Shot—Twice! (below)

There is a long and storied tradition of photographers catching themselves at both ends of an image like this. Yes, you see me in the center there just a little bit; had I planned this out better, I would have been able to run behind the throng of Episcopalians. As it was, it was a still a win, though, because the Chancellor (lawyer) clearly shook his head when watching me pull off the panoramic.

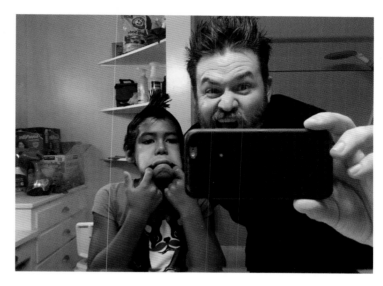

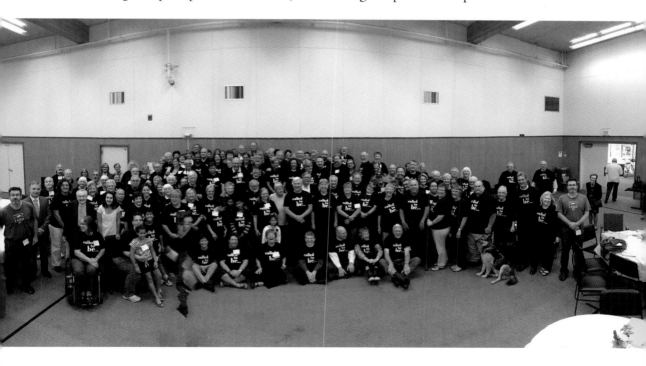

■ A Crowded Elevator (below)

Mirrors in elevators? Have fun—but within reason, people. Jeff's smiling face provides a sliver of reality for us to hold onto in this otherwise very crowded and jumbled image. Thanks, Jeff!

■ Elevator Panoramic

(bottom)

I probably could have worked the panoramic image a bit more while shooting in this county office building elevator, but I was on a tight deadline to gather up a proclamation and get to the grand opening of a Born Learning Trail. Otherwise, I probably would have ridden up and down a bunch of times. Fortunately, I had the elevator to myself.

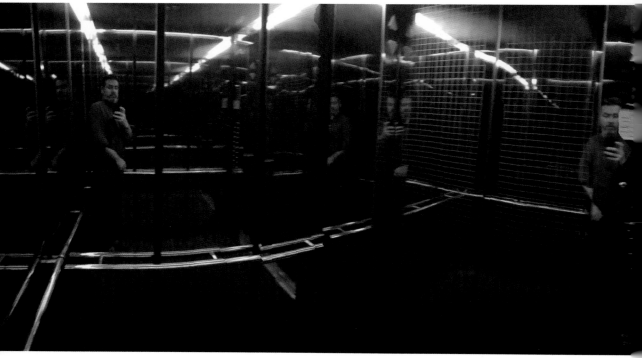

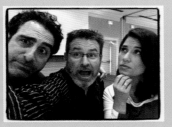
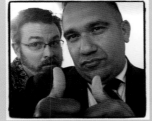

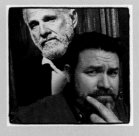

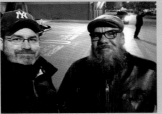
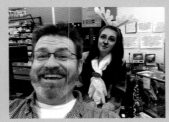

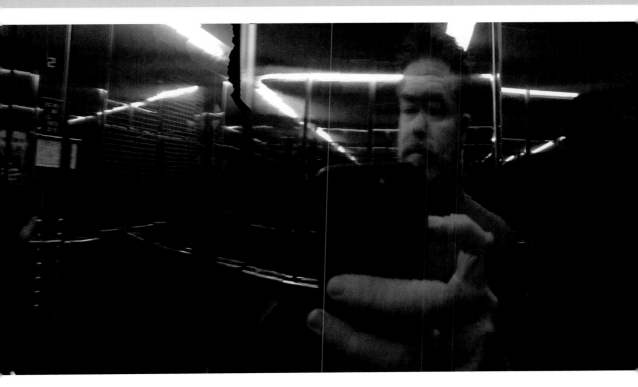

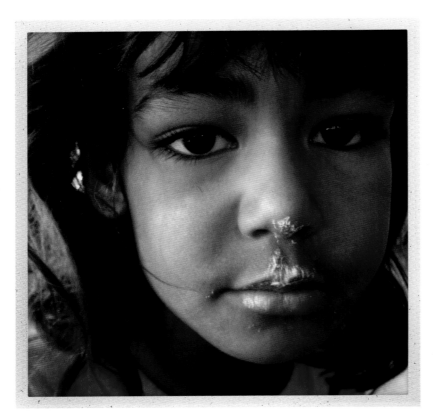

■ A Picture Is Worth a Thousand Words (left)

The nonplussed look on our daughter's face belies her cream cheese–smeared visage. You learn so much about our subject that you really don't need words from the photographer.

■ Amidst the Stars (below)

To be eight knocking on the door to nine and be able to lose oneself among the stars on the edge of the daughter/father dance. That is our remarkable young lady, able to look to the stars while staying grounded in life.

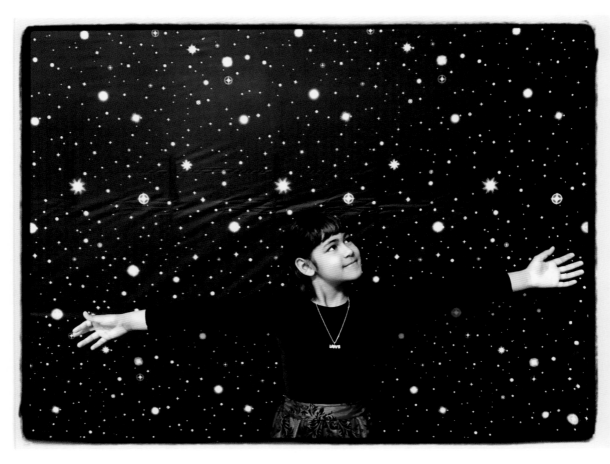

■ In His Element

Sir Thomas is out in his element. I am fortunate to know a number of remarkable people and Thomas is one of them. His honesty, kindness, strength, compassion, and insight are rivaled by few of my friends. We often find ourselves engaged in deep and interesting conversations while out on our rides—and that, perhaps, is all I really need to say. The miles pass quickly as we endeavor to solve all of the world's problems.

■ Provocative (right)

Troy Harvey is a colleague, friend, photojournalist, cinematographer, and owner of the very disturbing desire to eat many different kinds of processed foods. We made this portrait to send along to another friend, who would physically react to whatever Troy was munching on at the time.

■ Anticipation (right)

Before you can foster any child, you must prepare a bedroom—including a crib, if you are looking for a baby to enter your lives. Here, my amazing wife stands in the doorway of what ultimately became our daughter's room. Both she and Eeyore seem to be waiting, anticipating what might be in the future. This is the quiet before the storm.

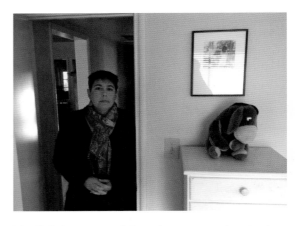

■ One of a Kind (below)

When they made Chris George, they threw away the mold—just to make sure it was never used again! I have not known a more loyal, honest, and hilarious person in my life. To say that he is a good friend is a failure of the English language. No other person has had me falling out of my chair, unable to breathe because I am laughing so hard at a story he is telling.

■ The Reverend

The Reverend Kenny Irby is an important mentor in my life and career. Our frank conversations about ethics, work, and faith helped me set out on my way—and he has remained a way marker for my photojournalism and filmmaking. Our faith has grounded both our work as well as our efforts in the world. I will never forget the day I visited his church and "got all up in his sermon." Just trying to keep you on your toes, friend. Thank you for everything, Kenny.

"Our conversations about ethics, work, and faith helped me set out on my way."

■ Be Ready

Quoting Louis Pasteur, my photography mentor W. Keith McManus liked to remind me that chance favors the prepared mind. If you have a iPhone 7+, utilize the portrait mode! The two lenses and software "magic" allow you to soften the background behind your subject. Chance may favor the prepared mind, but it also favors the photographer who controls their camera functions!

■ Just Ask (below)

All you have to do is ask—and let people know that they can say no. I ran into this mandolin player at a luggage carousel and noticed the *f* design on his right arm, so I asked him if he had a matching set. The answer was obviously yes!

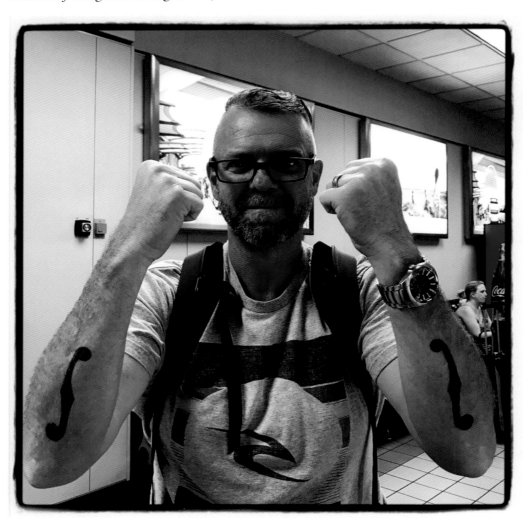

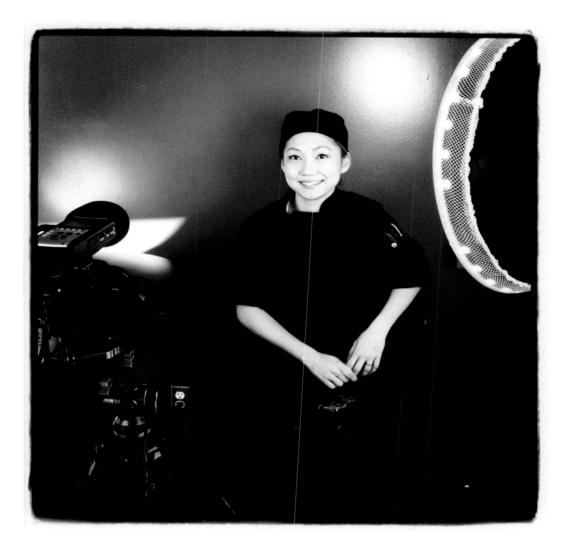

■ Chef Mai Giffard *(above and right)*

Chef Mai Giffard may be the hardest working person I know. Her work ethic and drive embarrass me on a regular basis. She is "force of will" personified and is putting in the work that will surely make her an "overnight success." She is an artist, both in pastry *(right)* and on stage. I am pleased to report that she also gives back to our community, encouraging other women to become entrepreneurs. The image above is a behind-the-scenes portrait of Chef Mai at the public kitchen space that she rented before opening up her own storefront in downtown Bakersfield.

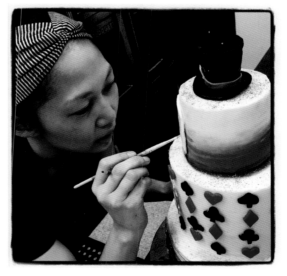

7. Sempre in Sella
(Always in the Saddle)

■ A Happy and Healthy Solution

A few years ago, my doctor informed me that my blood test results were not what they should have been at my age. Between moving into to my 40s and working a night job, I was not the picture of health. I told him that, rather than start on medication, I wanted to see if I could improve things with exercise—*i.e.,* riding my bicycle. That went fine for a few weeks . . . but then, well . . .

A number of years later, as I was helping plan and organize the Tour Against Trafficking (I eventually became the Tour Coordinator), a germ of an idea began to emerge: I could ride the Tour.

So, I started to pedal—almost every day. Fortunately, my friend Chris George was willing to be my exercise buddy and help keep me accountable for those first few months when starting was the hardest. My friends Zach and Fran then took over for Chris after he took a job out East—helping push me on distance and training, working on my diet, and helping me become a more proficient cyclist.

I wake up in the dark, get ready, get myself and my bike to the trail, and start out in the morning before work. In the beginning, it was not the easiest thing in the world to do—and there were challenges. For example, I had not been training for long when my mother, in her usual way, informed me over the phone that it was time to lose weight. I had not told her yet about the Tour or my

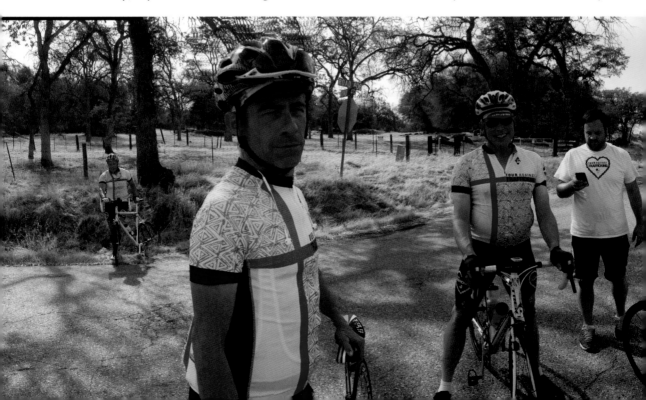

training, and I had broken a spoke that day on the bicycle I was training on (a loaner from Chris), so I did not take the helpful words particularly well. After time, however, the morning ride started to become something I enjoyed and looked forward to.

Many of you are probably shaking your heads and thinking, "I couldn't do that," or "You are crazy." Perhaps I was—but I am still on the saddle these days. I rode 4,000 miles the year of the Tour and was close to that again in 2016 (but a newborn baby put a happy crimp in that plan).

On the Tour itself, we rode just shy of 800 miles and raised over $54,000 to help combat human trafficking and fund programs to aid survivors up and down the San Joaquin Valley. We also screened my documentary film *The Trafficked Life,* and my life has not been the same since.

I found a lot of things out on the trail, and I know that I am one of many people who say that my life has been changed by both. I made friends for life on the Tour itself; you already met one of them (Sir Thomas) back on page 73.

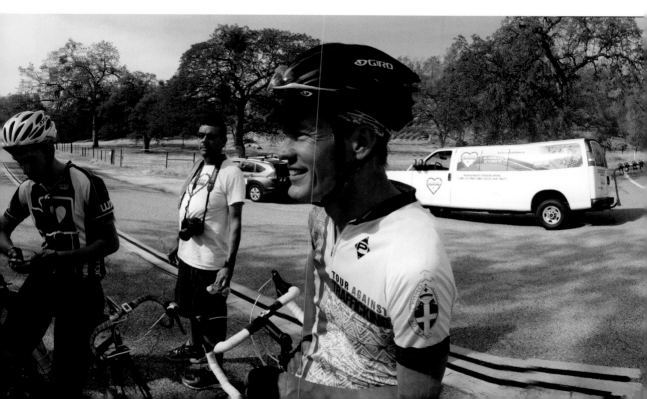

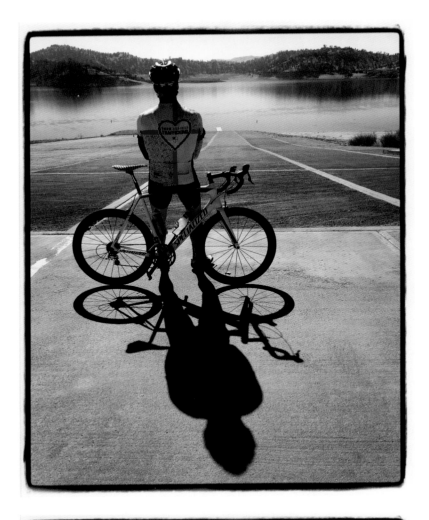

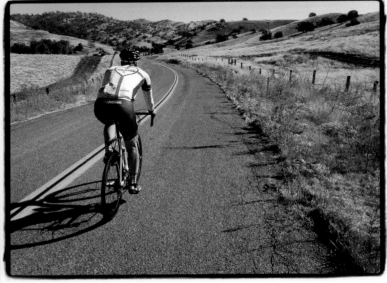

■ The Other Guy

One of my partners on the Tour is David Rice, Bishop of the Episcopal Diocese of San Joaquin (see page 31). On the second day of the Tour, after climbing 8,000 feet over 70 miles, we were celebrating the success of a teammate—an English-professor-turned-cyclist named Craig. Then David piped up, "I finished, too." We all looked at him, and I said, "You are the 'Other Guy.'" The nickname stuck.

Before you feel too badly for the Other Guy, I should point out that he has cycled around the world and competed professionally—so we *expected* him to excel on that day. Craig, on the other hand, did not know if he had an effort like that in him. He did, and he went on to claim the Polka Dot jersey for the Tour. This is a very unofficial award, and yet it fit Craig and his attitude to a tee.

■ No Shortcuts

We did not set out to do anything the easy way on the Tour. One of the churches we visited on our *hikoi* (Maori for a physical movement toward something) was in Ridgecrest, on the edge of the Mojave

Desert. That meant two trips across the southern Sierra Nevadas. (I asked the Other Guy if we could use vans to return to the valley after cycling to Ridgecrest. He replied no, so twice it was.)

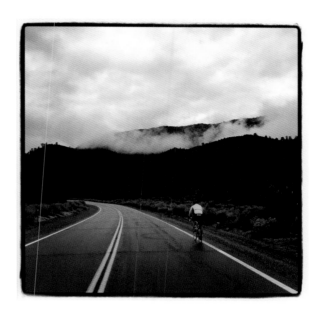

■ Enjoying Every Moment

We had a photographer/cinematographer on the Tour, so I did not have to take as many photographs as I might have. Most days, it was enough to survive the mileage and try to enjoy ourselves. After a rough start sleeping in a hot, stuffy room in Taft, the camaraderie grew to the point that we didn't want the Tour to end after we reached Modesto.

■ Comfort and Cleanliness (above)

Our kits had to be washed every night and hung to dry out for the next day's adventure. We had to get a little creative at times to find a place to hang things. (Probably the less said here the better!) We also had a lovely "game" that involved sharing a tube of Burt's Bees lip balm among the group—until a gentleman who heard our tales went out and bought a tube for every rider and our support crew. It was a lovely gesture.

■ Documenting the Tour (left)

Troy was our photographer/cinematographer and an all-around helpful teammate. Here he is standing along the northern edge of Lake Isabella as we headed out to Ridgecrest. As anyone who has cycled in the mountains knows, days that start out with sun might not finish that way—and we experienced rain as we crested the east side of the mountains and rode into Ridgecrest. Fortunately, a deep tissue massage therapist had heard about our efforts and volunteered her services. Her work was very welcome after we warmed up from that day's ride.

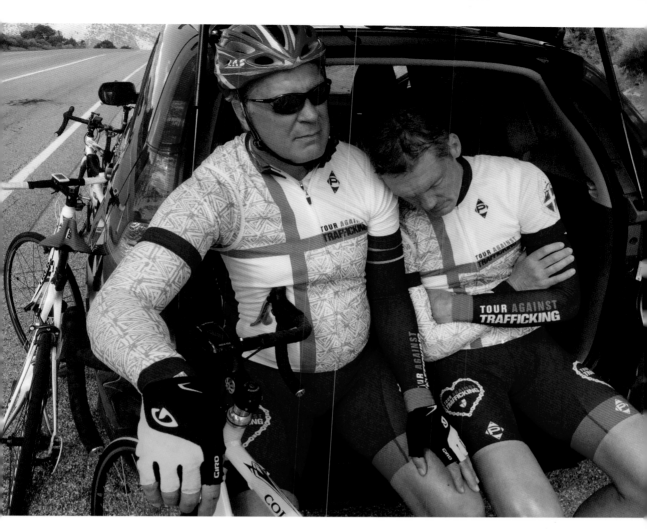

■ Brotherly Love (above)

Is there anything more brotherly than allowing your teammate (and actual brother) to rest his head on your shoulder? Lars had to have broad shoulders for all of the jokes he lofted and received in kind. In addition to being the brother of the Other Guy, he was a master of working a deal.

■ The Professor (right)

Craig, or the Professor as we occasionally called him, quoted Tolkien to me as we headed toward Walker Pass and these looming clouds. I am not sure if he thought we were headed to Mordor or off on an adven-ture—and I must admit not wanting to know the answer to that question. He was a selfless teammate and a great addition to our *hikoi*.

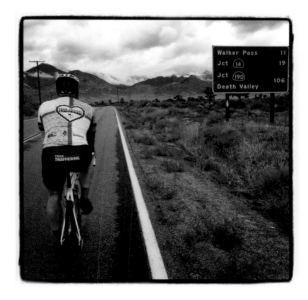

Humor (top left)

One of our team-mates had an especially great sense of humor. Here, Zach did his best impression of *Kilroy was Here* as we mapped out the Tour and each of the days' efforts. In one sense, this was the hardest part of the endeavor—minus a quick trip to Fresno to placate some politicians. Zach brought some much needed experience to the team and now we have a new anti-human trafficking advocate.

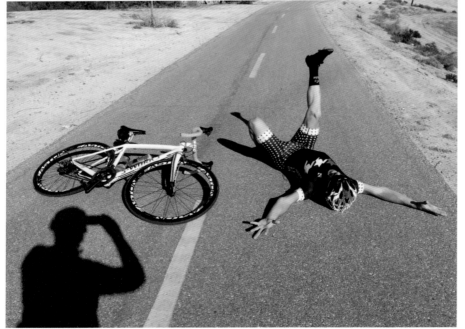

Rider Down!
(bottom left)

Perhaps "a great sense of humor" is underselling things a bit. This was our re-creation of "cyclist down." I am not even sure why we were doing this—but I am glad to report that no cyclists were harmed in the making of this image.

■ Sir Thomas (right and below)

Another teammate on the Tour quickly earned the title "Sir Thomas." He rode with us on the infamous Day Two—the hardest day of riding on the Tour, on which we climbed 8,357 feet over 72 miles. At the top of the pass, he turned around and rode home on his bicycle for a 100+ mile day on the saddle.

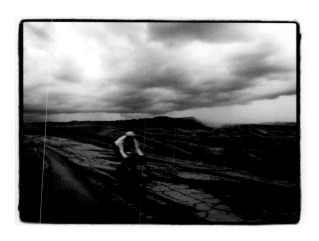

Sir Thomas later decided that he was going to make an Everest Attempt, ascending 29,029 feet on one stretch of road, literally going up and down the same hill for a little under 24 hours. He did nearly 42 "hill repeats," as we call them in cycling—but who's counting? Sir Thomas did not have a lot of luck in the weather department, but he managed to tough out the ride. I'm still not sure why he felt compelled to do this, other than that it was there. I came along and offered "sherpa" services for an evening, essentially riding alongside and talking—or in many cases just sweating and pedaling! (More about Sir Thomas on page 73.)

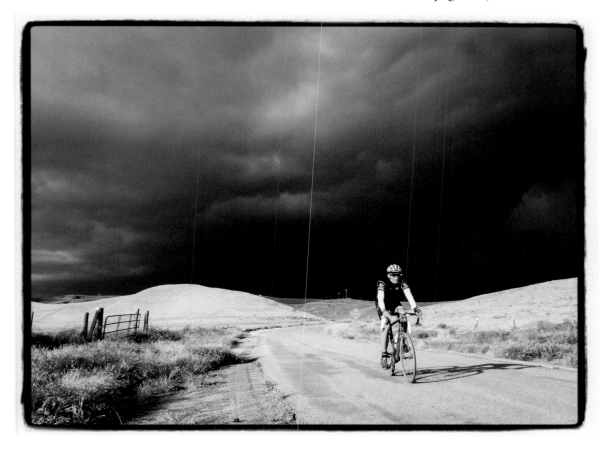

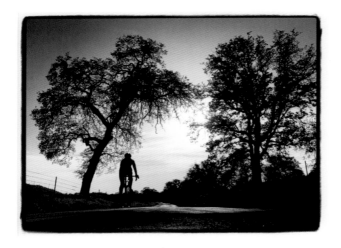

■ Gary (top left)

The most recent teammate to have joined us is Gary, who might still regret this decision. He will be joining us as we bring eight riders to the Death Ride in July in the California Alps. The mountain passes 15,000 feet of elevation to be gained over 129 miles in one day. I shot this image from a low angle while Gary and I were heading back to our car on the way home.

■ A Tough Choice (bottom left)

Gary gets another one of my "you pick 'ems." Both of the photographs to the left work well, both have Gary in them, both were shot from a position kneeling in the road, and both are backlit. Which is better? I like both of them—don't make me choose.

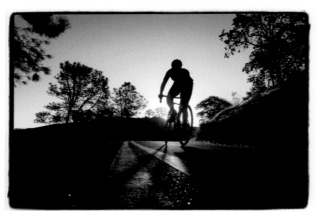

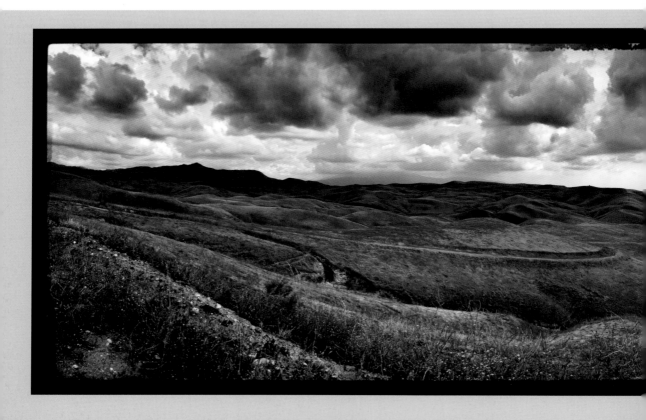

■ Climbing (right)

To train for climbing, you have to climb. For my group, that happens most often on the weekends, when we have more time to ride. Here a truck comes up the road from Woody, CA. It is a hike just to get here—and this is only about halfway up our Day Two on the Tour. This is the color brown we normally see in the mountains and foothills.

■ Sweat Quotient

Getting many of these images involved a huge sweat quotient. This is one of the reasons I quite like my camera phone—it fits comfortably in my jersey pocket and can be easily reached while on the road.

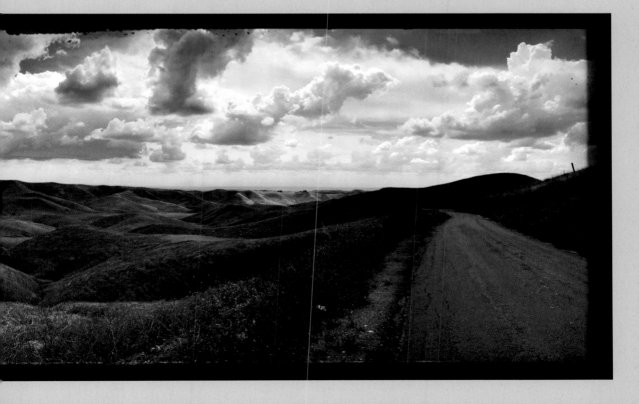

■ Into the Light

(top left)

Every now and then you get lucky and the tree branch blocking the direct sun and the bike lane sign all line up! I see so many good images along Panorama Drive. I really should go back there with my pro gear—but that never seems to happen. If I am up and riding and happen to see something though . . .

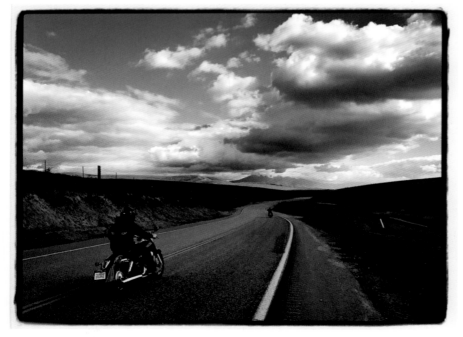

■ Sharing the Open Road (bottom left)

I pass a lot of motorcyclists out on the road. Most of them will give a friendly wave; others seem more taciturn. In one sense we are kin, sharing the road, and yet we experiencing things very differently—especially when you compare our outfits. That said, there is nothing like seeing the open road ahead.

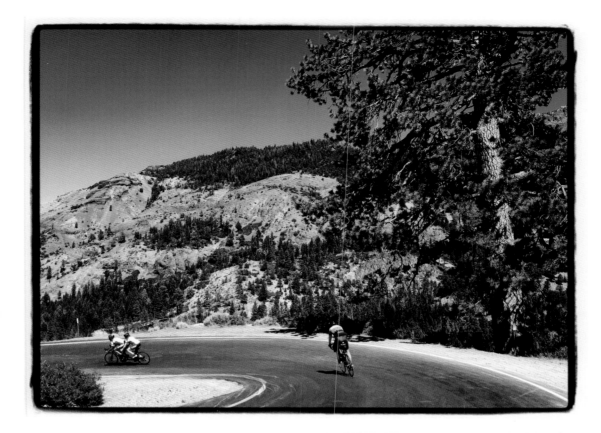

■ Downhill (above)

Heading downhill from Ebbetts Pass is as technical a bit of descending as I have experienced—especially with the amount of wind the course saw in 2016. Thankfully, the Death Ride organizers put helpful little signs about when to brake. Looking over the edge of this tight turn made me glad I had stopped to pull over and take a few frames.

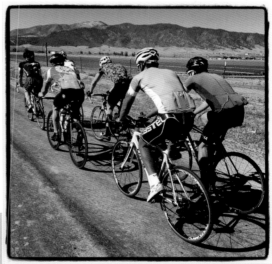

■ Pros

This may be the closest I will ever get to riders in this class. This group has two current pros, one former pro, and one national team cyclist—and I was fortunate to keep up with them heading out of Tehachapi. They dropped me when the real climbing started.

I am in much better shape and noticeably lighter than when I made this photograph, but they would still drop me tomorrow—and that's okay. I will keep battling to stay with them. It's all about the race within myself.

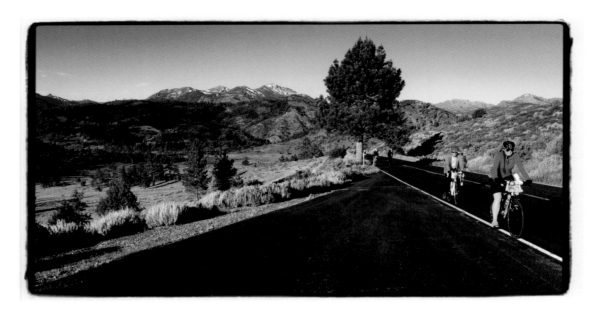

■ Ride Your Own Race <small>(above)</small>

One of the lessons I learned early on in cycling is that I am really only riding my own race. That took a while to learn—not unlike photography. I can keep competing and comparing myself with others, but if I am making images better than I did last year or I have learned new techniques, then I am a better photographer than I used to be.

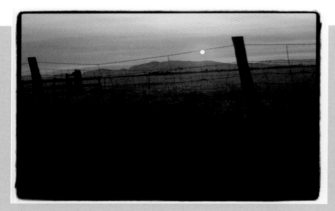

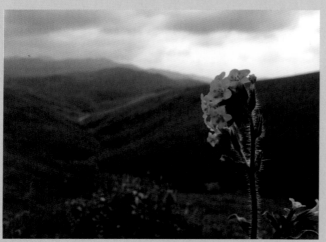

■ Learn and Teach

I ride with folks better than myself when I get the chance because that makes me a better cyclist over time. I also talk with and show my work to other professional photographers and look at students' work because that helps me get better as a maker of images. One of the best things you can do to *learn* is to break down your skills and teach them to others. I find I have a much better understanding of things after I teach them.

> **"That helps me get better as a maker of images."**

■ Balance the Elements
(right)

You might be saying, "I thought this was the cycling section, Mike—not the Taoism section." Can't it be both? There is nothing like trying to balance out all of the elements in an image, giving them each their proper weight and position. Figure out what caught your eye and how to bring that forward. In this case, the sky and clouds balance out the ground and pump jacks because they get more physical space.

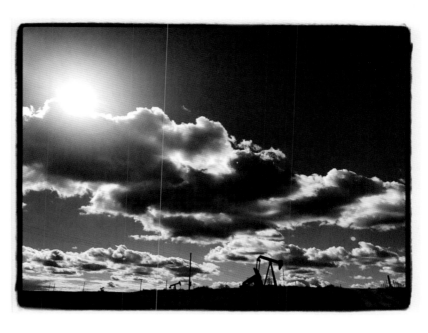

■ Shoot What's in Front of You (below)

You can complain or be upset about what you *don't* have in front of you until the cows come home. Instead, I think it's a lot better to work with what you *do* have in front of you. Accept what is there and then figure out how to make an interesting image. Here, the distance in the image is conveyed from the blue tint of the fog in between ridges. Add a fellow cyclist for scale and we are cooking.

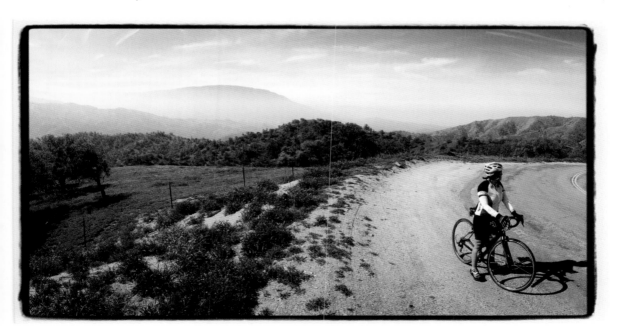

■ Keep Looking (above)

Keep looking for that image that speaks to you—that works. Life is too short to make dull images. Figure out how to motivate yourself to get out there every day and take a picture. It is just like shooting free throws; you have to put in the practice. This is why I have thousands of images on my phone!

■ You Never Know

I never know what I am going to see along the road. Don't worry, this is just a toy gun—although I have seen someone lose a rifle in a case off the back of their pickup truck, too. I'm not sure what I am saying with this juxta-position. Sometimes it is better for the viewer to draw their own conclusions.

■ Your Passion

Think about that passion or hobby of yours and bring photography with you. "Hey Mike, photography *is* my hobby," you might be saying. I hear you! Then take a page from martial arts or religion and make photography your *practice*. I am always learning, always observing forms, seeing how I can push, ignore, or mangle guidelines. Figure out how to bring your visual efforts to something else. The push and pull of different modes of thinking can be *very* helpful.

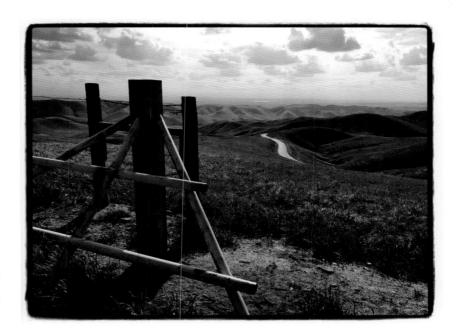

■ Variations

There was a reason that Mozart did variations on themes. So steal that great idea! I have photographed hundreds of bikes and cups of coffee. Will I show them *all* to you? No. But the discipline of making that similar image over and over again will pay off. Over time, you will start to think more creatively about how to do it better or differently.

9. Almost

■ The Cruelest Word

I often joke that the cruelest word in photography is "almost." Maybe it isn't a joke. For many years, I kept a file of "almosts" on my computer, and if I really wanted to beat myself up, I would look through those images that almost worked. Many were just missing something—the composition was there, but it was not the right moment, or the moment was right but the lighting was off. You get the idea.

■ Learn from Mistakes

It is easy to look at images in a book or in a presentation and think, "That's a great photo"—without really be able to say much else other than it works. One of the bravest things I experienced as a student was when *The Washington Post's* Michael Williamson came to RIT and showed us (I'm dating myself here) an entire slide tray of images that didn't work. Then he talked about those images. You know what? I learned more from those images than a year of photography classes. It took courage for Michael to do that, and I have thanked him publicly for doing that.

All too often, though, I tell my classes that story—and then forget to close the loop by showing some of my own near misses. I'm going to correct that in this chapter!

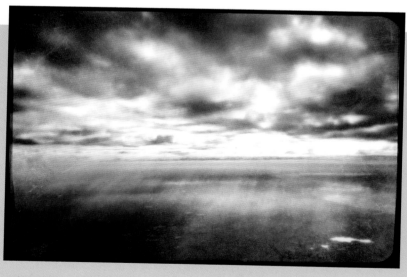

> **"It is like a set waiting for an actor to appear and do something."**

■ No "There" There

In this image, I love the clouds. I also like the rays of light, the texture, and the pattern of light on the water . . . and yet there is no "there" there. What are we supposed to feel? Where should our eye wind up? It is like a set waiting for an actor to appear and do something. There are times I wait all day for that actor and go home sad or frustrated. In this case, the plane kept flying, so I waited.

■ Try, Try Again (above and right)

I love these fish, the pool, and the light reflected on the surface, but I couldn't make it work. I tried for a good amount of time. I even tried video. Nothing worked.

When this happens, it's easy to be hard on yourself, but it can also teach you a lesson—if you listen and look carefully. In this case, what could I do differently? Perhaps I could have come back at a different time of day. Perhaps stronger lighting might have helped. I could have waited until someone fed the fish. Maybe I could have tried to be more abstract or tried to use the graphics of the light reflection more to my advantage? You can do this to learn or you can do this to suffer—it's your call.

When I got stuck on assignments at the newspaper, I would literally shoot with every lens in my camera bag, trying to force my eye and brain to "see" something new. There

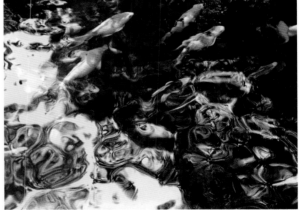

are times when we think we know what the image *should* be but can't pull it off. The trick is to discern when it isn't going to happen— when you are blind to the potential because you are trying to force the wrong idea.

What I appreciate about photography is that there is always another day and there is always another subject. Pixels are free, so keep making images. Keep plugging away.

■ Cute, But Not Quite There (top left)

I am not sure how ducks became our thing for our bathrooms in every house where we have lived, but there you go. Now, the ducks mirror our (possibly growing) family structure—and yet, the image doesn't work. It is cute, and it recalls the figures people put on the rear windows of their cars, but that is where it ends.

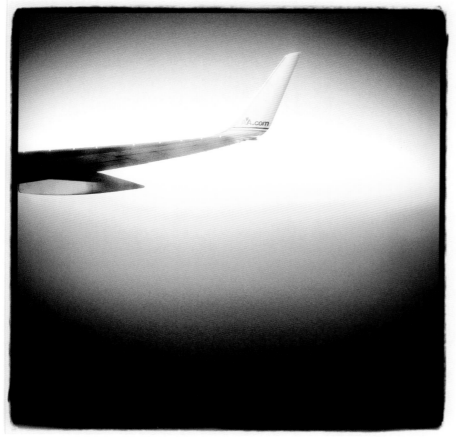

■ Not Enough Story (bottom left)

There is a lovely airplane wing, interesting vignetting, and a color palette you don't often see. My eyes also move around the image. Unfortunately, there is no place for it to end. All it really says to me is that I was on an airplane.

■ Not Enough Personality

(right, top and bottom)

You might get the idea that Lars spent a great deal of time lying down on the Tour. Sadly, I have to say that I was not able to capture his "Lars-ness" or his "lying down-ness" all that well, despite my efforts. I will tip my hat to Troy Harvey, who got the definitive image of Lars, one we entitled *Lars of Arabia*. Troy also got a great image of me lying prone on this same day. In defense of Lars and myself, this was probably the second or third hardest day on the Tour with a great deal of climbing on 11 to 14 percent grades, long descents, and then rolling hills and wind as we finished the day in Porterville, CA.

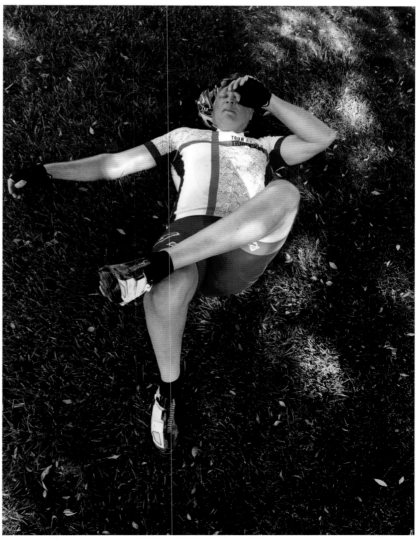

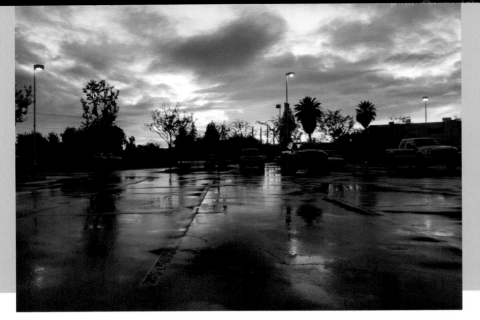

"The storm had cleared and the setting sun was beautiful.**"**

■ A Missed Opportunity *(above and below)*

This may be one of the few images that really haunts me. I came out from food shopping to find a storm had cleared and the setting sun was beautiful. So, I started working—in the parking lot. I knew the light would not last long and that there were no scenic locations within driving range, so the parking lot it was. It was frustrating to say the least. I tried as hard as I could, but to no avail.

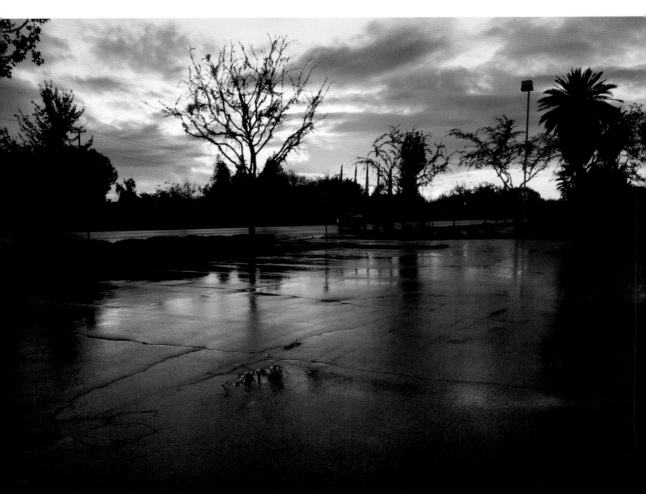

■ It's Not Saying Anything

(top right)

I really liked the chalk from the tread of my sneaker. I tried making the colors more saturated, and I tried shooting 180 degrees from this perspective—but nothing worked. It just isn't saying anything. Perhaps if there were a series of footsteps it might have been better.

■ Needs a Different Perspective *(bottom right)*

Folks were praying before the start of Love for Thanksgiving. It was a nice, quiet moment—and yet, nothing. This to me is halfway. I either needed to back up farther and show the parking lot or get much closer to show faces and/or hands.

Once, while I was in Afghanistan covering the 10th Mountain Division, I was excited because I jumped into a swimming pool with my subjects, who were getting baptized. You guessed it—as my photo editor Norm Johnston pointed out, the best photograph was actually taken while I was simply standing on the deck. It showed the entire pool, with a subject getting baptized in the foreground and a patriotic flag–emblazoned inflatable raft in the background.

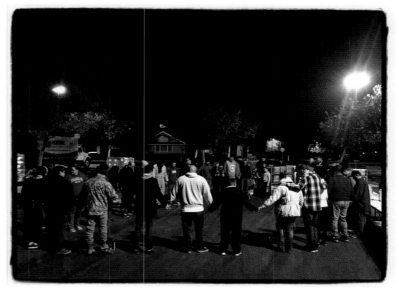

> **"I either needed to back up farther and show the parking lot or get much closer."**

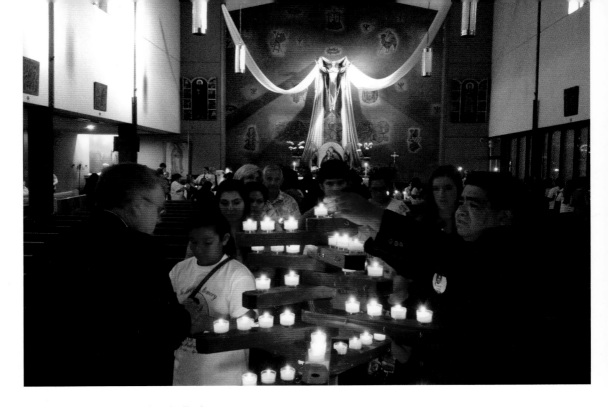

■ There Should Be Gold, But . . . (above)

There should be gold here somewhere in this scene, right? There is candlelight, a church, a giant cross, and the theatrical draping of cloth. The candles are even illuminating the faces of the people. I tried a higher perspective to minimize the background, and I tried shooting tight on the candle tree—it just wasn't happening.

■ A Problematic Background (left)

This one should work, too. We have a cute young girl, wearing a winter hood, sitting on polar bear, on a stage—and yet, something is not right. This is one of my favorite children in the world, Emi, and she believes that church is a giant musical (and why shouldn't she?). I think this is a case where the background is not helping us. I tried framing this vertically and horizontally, from closer and farther away, but nothing worked. She's still an amazing child; the photographer just couldn't overcome the challenges.

❝I think this is a case where the background is not helping us.❞

■ Lackluster Lighting (right)

Storm clouds, rain and mountains on the horizon, a strong diagonal . . . why wouldn't this work? Yup, the light isn't dramatic enough to pull this off—nor is the lens on the iPhone camera. The wide-angle lens shows us too much of the car. Yes, it is a framing device, but there just isn't enough in the framed space on the right to hold our interest.

■ No Value-Add (below)

Dramatic light, check! Warm light on the subject and storm clouds in the background, check! Lady Liberty mural and graphic shape, check! Result? Nope. This image needs something else—a bird flying through the frame, a lost balloon, a person with an umbrella in the foreground, take your pick. Otherwise, this is just another's artist's work, lit beautifully by the sun and with ominous clouds in the background. There is no value-add from Mike.

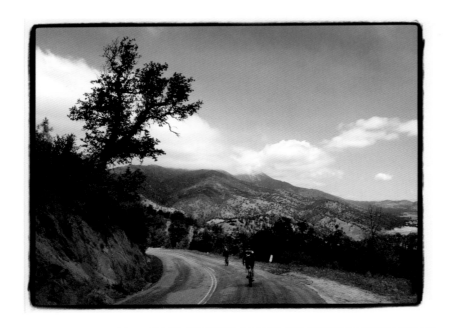

■ Ineffective Framing

(top left)

Framing device on the left, check. Foreground, midground, and background, check. This is about three-quarters of a successful photo. There just needs to be something in or covering the upper right quadrant of the photo. When I test how my gaze moves through the photo, it travels to the upper right and then out of the frame.

■ Missing That "Something Extra"

(bottom left)

It is worth taking risks. These were literally the last two leaves on this tree; they contrasted nicely with the Oleander on the right and the lawn in the back. The use of selective focus helped, but this is just missing that something extra to make it special.

"This is just missing that something extra . . ."

■ So Close (top right)

This sad, lonely tree almost made the cut for a different section of the book, but it wound up in the "almost" folder. The vignetting of the frame almost pulls it off, and the last bit of sun hitting the ridge across the river helps. But I was unable to get lower to really set the tree off against the sky and that empty white space just drains the photograph. As my Photo 1 instructor Millard Schisler would observe, our eyes are drawn to the lightest part of the image and in this case there is nothing there.

■ Nowhere to Land

(bottom right)

More clouds—big surprise, right? The bottom third of this photo is working (and yes, officer, I made this while in the passenger seat). Again, though, we are left waiting for something happen where our eye winds up—and it doesn't. It's the photographic equivalent of *Waiting for Godot*.

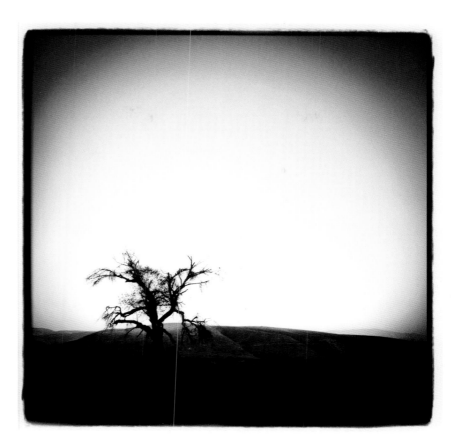

the seamless and other studio detritus. I don't even mind the incandescent lighting at the top. I guess it's an "almost" because the subject is so aware of the camera and playing to it. It's a fine line sometimes.

■ Splash (below)

Lars gets another mention. I like the peak action in the bottom one-third of the frame. The tree and the house in the background are not really contributing to the photo, though. I tried using the zip line as a diagonal and showing folks coming out of the pond but nothing really worked. But we did have a great deal of fun—and that was probably far more important!

■ On the Bubble (above)

This is one of those "on the bubble" photographs that could probably have made it into the portrait chapter. I like the body language and the look on our subject's face. I don't mind getting a "behind the scenes" view of

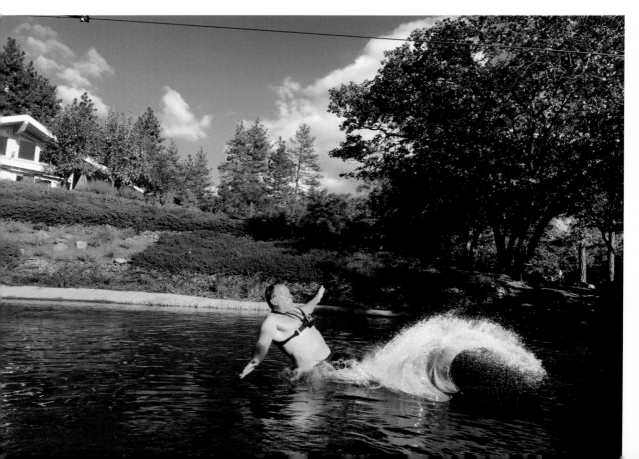

■ Too Many Words (above)

I don't dislike this image; it is more an "almost" because of all of the words. Standing on the steps of the U.S. Capitol Building, Michael Williamson once asked a group of young photographers a good question: "Can you sell your photos today to the international market?" He was really asking, "Are the words on the sign making your photograph work?" As much as I like the contradiction of these signs, the message is not enough.

■ Not Every Cloud (right)

See? Not *every* cloud image made the cut. I do like the heart shape to the cloud on the upper left and how the base is grounded with a nice diagonal coming down from the right side. However, other than the heart, there just is not enough going on here to keep a viewer engaged.

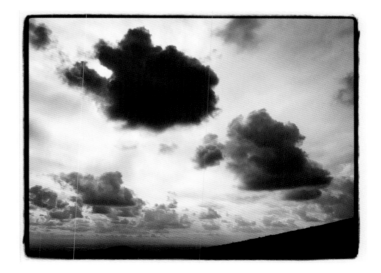

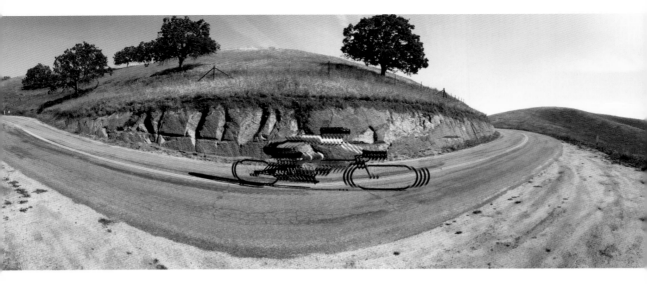

■ Low-Impact Panoramic (above)

I kind of like this image, but it doesn't quite go far enough. This is what happens if you shoot in panoramic mode as someone rides past on their bicycle. I will be trying this again in other ways—so this counts more as research, but it is still also an "almost."

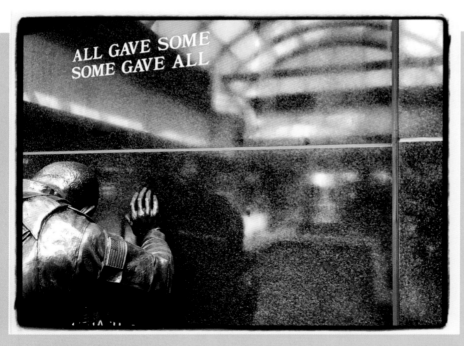

> **"The words and statue pull my eye away from the reflection."**

■ Not Quite Enough

This image highlights the danger of trying to replicate an idea from previous shoots. I really like the reflection of the flag, sky, and arch, but the words and statue pull my eye away from the reflection. Once again, the artist who brought the memorial to life has a larger role in this than what I brought to the table as a photographer. I am still glad I worked the scene.

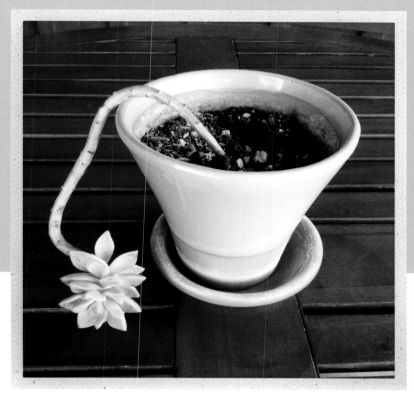

▪ A Few Issues (top right)

This is an interesting little flower, but I don't think I did enough to transform the moment or make the effect of the flower stem really stand out. Also, the surface of the table is not helping us; the slats pull my eyes to the top of the frame. I'm not sure I have any other solutions for this one.

▪ Close, But . . . (bottom right)

So close. I love the leaf and mocha swirls on the drink. I don't even mind the mixed lighting or the marble background. At the end of the day, I think the problem is the location of the cup handle at the almost-noon position. It just doesn't feel welcoming. I like having the foam pattern on a diagonal, but the handle falls short.

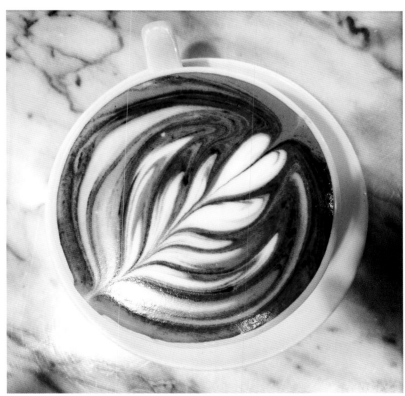

■ Shadowplay (right)

This is another multi-lighting situation and an homage to Duchamp. However, this photograph shows the importance of the background material. Wood or laminate just does not carry the image like plaster or paint. It adds some funky texture where we don't need any. I love the deconstruction of the chair, but just not with this surface.

■ The Wrong Lens (below)

This is one of those times I should have just kept pedaling. I love the rising sun reflected off the mighty Kern River, but it just isn't enough. The good news is that the highlights on the river keep my gaze where I want it to wind up. This would have been a great image to make with a long lens and my 35mm camera, but I don't have that with me on my morning rides.

■ A Silly Moment

(top right)

I am still not sure why Chris put this plate on his head. I love the absurdity of the portrait, but once we get past the silliness, there is not much else here. I love that I have a friend willing to do this, don't get me wrong. If someone (particularly a child) had been shown looking at the cookie, then we would be going somewhere. A really good portrait should give you at least two layers of insight. Sadly, this only gives us one.

■ Lackluster Silhouette (bottom right)

The room where I made this photo was super dark with really strong side lighting from the windows. I tried to take advantage of my subject's dreadlocks, but it just doesn't work. There are times when you take chances and fail. This would be one of those times.

■ An Unusual Subject Is Not Enough

(left, top and bottom)

A cat on a desk is not something you see every day at the office, but this is the "business cat" at a printing shop in town. I couldn't get this shot to work before the cat decided not to "work" with me anymore. I was able to get two or three frames off and then our session was over. I did not have the courage to ask the cat's personal assistant if we could book a reshoot—and I must admit I have not seen my feline friend since this visit. I will consider him missing, presumed fed.

"I did not have the courage to ask the cat's personal assistant if we could book a reshoot."

■ Shoot Everything, Edit Heavily (top right)

It is worth shooting almost everything you see, but then edit heavily. I really like the sun peeking up over the mountain; this was right before the rising sun overwhelmed my camera's sensor. The power or phone line is certainly helping the composition, but it's just not enough. Something in the foreground might have saved this image.

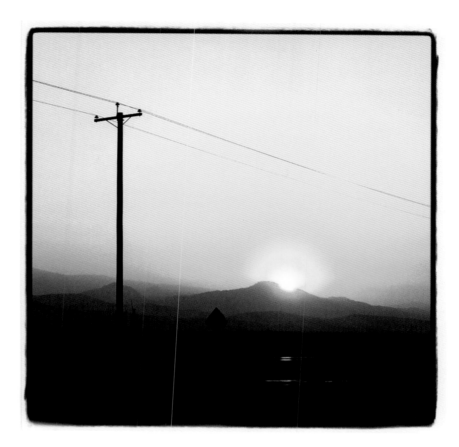

■ Missing Something (bottom right)

Like the image above, this image is lacking something. If there was a jogger or runner to frame against that sky we might have had a more successful out-come. The transmission lines and towers are helping, but the bottom right one-third of the photo is just too dark and there nothing interesting down there.

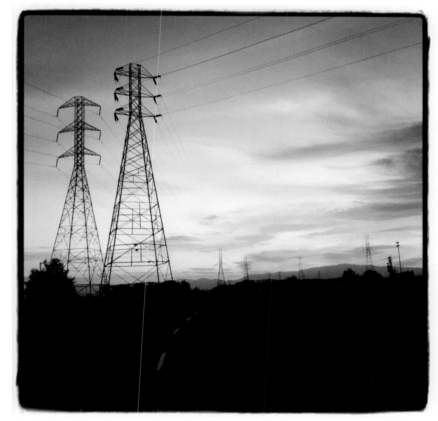

■ So Close!

(right)

I love the long shadows from the morning sun in winter. I like the sense of motion. I love the spot color from the book bag, too. However, the "amputation" of our subject's right leg moves the photo to the "almost"

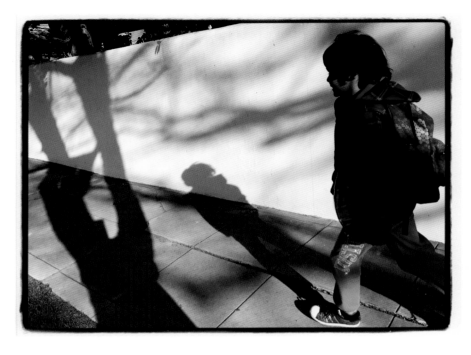

section. The trouble was, getting far enough away to fit her entire body in the frame ruined the shadows. We have to be very careful where the frame edge falls on subjects' limbs, especially on their joints. Cropping them looks painful and causes me to wince at times.

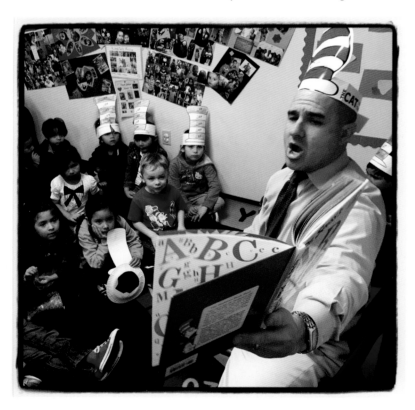

■ The Kids Are Not Selling It (left)

I love the energy of our reader. He is really selling Dr. Seuss. The primary problem is that the children do not seem that engaged. We have a good foreground, midground, and background—but the children, while cute, are not selling this photograph for us.

"The second shot is very powerful to me except for one tiny detail ..."

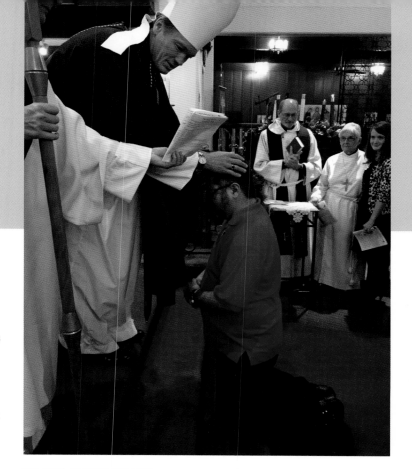

■ A Personal Connection

(right, top and bottom)

You probably recognize the "Other Guy" (see page 80) in his official capacity. These images carry weight and importance for me—but, sadly, it's because my friend Darren is no longer with us. He was a practicing Buddhist before coming to our church. He was also a substance abuse counselor who liked to say that he had years of extensive field research. He helped so many people that I felt lazy in comparison. Also, people often mistook us for brothers (I can't imagine where they got that idea!). The world is a darker place without my friend.

The second shot, where the Bishop is looking directly into Darren's face, is very powerful to me except for one tiny detail: that piece of red carpet behind his face that makes it look like he is sticking his tongue out at Bishop David. With a crop from the top that image could work; it is certainly the right moment.

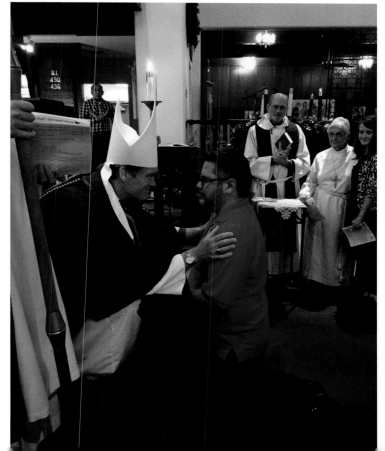

10. Personal Vision

■ A Long Process

Perhaps the hardest thing to do is find your personal vision. We even had a class in this at the Rochester Institute of Technology, led by Gunther Cartwright. Thinking back now, I totally get the idea behind this class. Sadly, like all but one or two of my classmates, I know I was not ready to get everything I could out of the course at the time. I am glad I was exposed to the idea and had something to look for and work toward—but it took

years of being a professional photographer to even come close to finding my own vision.

■ Emulating the Experts

Almost all of us start out emulating the work of photographers we like. I went to school thinking that I wanted to be the next Galen Rowell, and my first semester at school I was devouring the work of Sebastião Salgado and James Nachtwey. I would like to blame my professors, but I think that falls squarely on

me. I was also shown the genius of Elliot Erwitt and that made the difference for me.

Be True to Yourself

Until I encountered Elliot Erwitt's work, I was a "serious" photographer. I had my light meter, my range of black & white film, and I was going to document *something*, by golly.

Then, I learned that my sense of humor was important to include in my work—it was more authentic to my personality to have some fun and not be a completely serious, academic photojournalist. That was a good lesson to learn. Without that important step, I don't think I could have made many of the images I am most proud of today—even the serious ones. If your work does not reflect or illustrate who you are, it is not as going to be as strong as it could be. (This is *not* advocacy for shooting more selfies, by the way!)

So, I will continue to photograph a toilet in the middle of nowhere, with two strategically placed buckets and let the viewer wonder why or how *(facing page)*. Yes, I will miss the person jumping into the pool and show you, instead, their splash lit by the evening sun—because it raises more questions than it answers *(above)*.

Asking Questions

I don't like making statements; most of the time, I prefer to ask questions. I like pointing out juxtapositions, making the viewer wonder what they are looking at, and adding layers to my work. This is much harder with the

limitations of a camera phone, but that is part of the payoff when it works.

Hugh Brody has a great quote that I almost always share with classes:

> The hunter-gatherer mind is humanity's most sophisticated combination of detailed knowledge and intuition. It is where direct experience and metaphor unite in a joint concern to know and use the truth.

I can't think of any better description about my work in photojournalism and photography. So, yes, we need to know some physics and terms, but we also need to listen to our intuition. The following images happened; some of them—a few—might also reveal deeper metaphors.

■ A Fan of Escher

(top left)

I am a fan of M.C. Escher and Josef Albers—we even had an Albers or two on campus at RIT. In this image, I am trying to play with proceeding and receding space—as well as your sense of place. This is part of a wall at Dagny's Coffee Company in Bakersfield, but seen just a little differently.

■ Ode to Duchamp

(bottom left)

I am also a Marcel Duchamp fan and this is my ode to his body of work. While he was known primarily as a painter, he was partially inspired by time-lapse photography—so why can't photography be influenced by him? I am not sure how there were multiple light sources hitting my subject, but it really plays with your sense of perspective and I like the quality of movement it suggests.

■ Working It (above)

While teaching on the Bakersfield College campus, I took a quick trip to the bathroom before starting class. I noticed how people were silhouetted by the giant window on the staircase, as well as the random quality to the lights hanging in the stairwell. I think the class started on time—but I really worked this situation.

■ Ice or Rain? (right)

It's hard to tell if this is ice or rain, and I think that is part of what I like about this image. You get a sense of wet and a hint of sky as well. In fact, it is a puddle on stone that reflect-ed the sky through an architectural opening in a building. See? It's not quite as interesting once you know what it is.

■ **Found Art** (top left)

I love the dinosaur breaking through the photograph. Then, make a photograph of a photograph and we get meta rather quickly. In one sense, it is just a humorous found photo of a photo, illustrating my sense of humor. We are always trying to break through that barrier of the frame and limits of 2-D when we work in photography, so perhaps this is my not-so-subtle attempt at 3-D.

■ **Speedy?** (bottom left)

"Man—that snail is really moving!" said no one ever. But what makes this work? It is the regular dashes of the snail's trail. This is the same convention used to show movement on the comics page of your local newspaper. Comics have been using this technique for many years, so why not use the same device in photography?

"Comics have been using this technique for years, so why not use the same device in photography?"

■ Spectacular Light (right)

The light in this outdoor mall in the San Fernando Valley is just spectacular. It doesn't hurt that the playground looked cool, too. Add in the children all over the structure and your eye has a feast to enjoy.

■ Abstract Blur (below)

While eating lunch with a colleague, I noticed how this window blurred the murals in the alley behind the restaurant. I think this is probably a triple, not a home run. It needs a little more separation between the subject walking and the wave in the glass—but there is only so long you can bend over shooting images out a restaurant's windows before someone asks you what is going on!

■ Oily Rainbow (right)

Yeah, we have all seen this—but did you take a picture? There are some interesting things happening here, particularly because I toned the image so that the asphalt essentially became black with white rocks. It could be stars! Now we are talking a supernova and things get far more interesting.

■ Backlit Sprinklers (below)

During the drought in California, someone was risking a fine from the city for wasting water. But all sorts of things start to happen when you can backlight a scene. There are strong diagonals from the sprinklers as well as bright highlights from the sun.

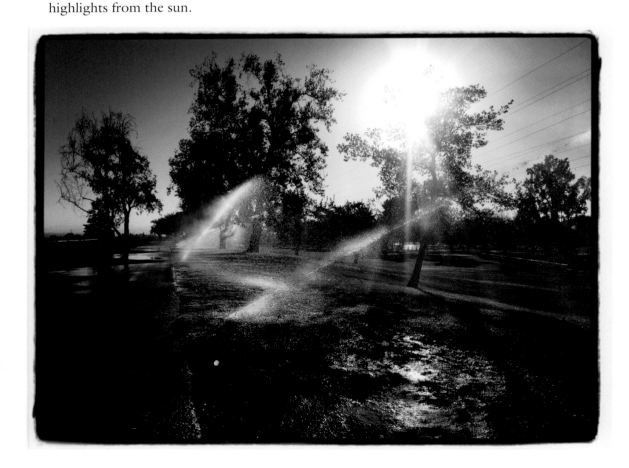

■ To the Limit (top right)

Push your gear to the limits. This is such a typical scene in Bakersfield; the sun had already set, so the primary light was from a street light. I love what the moon was doing to the clouds in the sky. There is a mood here and it makes me wonder: if this were a movie set, what would happen next?

■ Decorative Lights (bottom right)

Who thought decorative lights along a sidewalk could be so much fun? Walking home through our neighborhood from a friends' house yielded this little moment. Our part of town has a much different feel at night. Visit local areas at different times of day to see how the light, or lack thereof, affects what you see.

> "Visit some areas at different times of day to see how the light, or lack thereof, affects what you see."

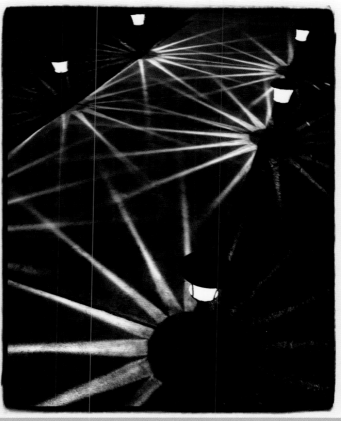

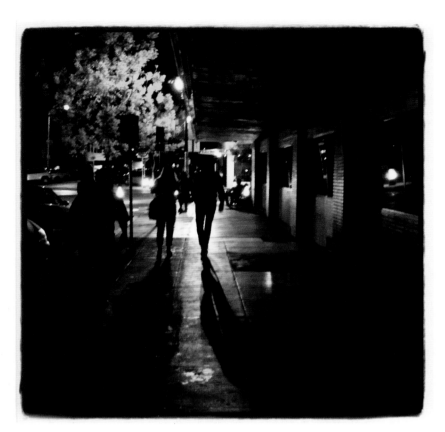

■ **Mood Lighting** (top left)
Walking back to our car
after doing something
downtown, the light
had faded. I photo-
graphed this couple
ahead of us; the city
lighting and the side-
walk all work together
to set a lovely nighttime
mood.

■ **Number 13** (below)
Is the number 13 raised
or recessed? Let your
eyes move it back and
forth between those
two "positions." Josef
Albers might have some
fun with this, too.

■ Trees Two Ways

In the image to the right, we see steam rising through tree branches that were illuminated by a light in a parking lot. It seems kind of dull when we talk about it that way—but is it interesting otherwise? Do the shadows from the branches do interesting things?

The image below shows the sidewalk at an outdoor mall, shot in the rain. There is an interesting amount of detail in the silhouettes of the palm trees. I worked this situation from a bunch of different perspectives but decided that this orientation was the clear winner.

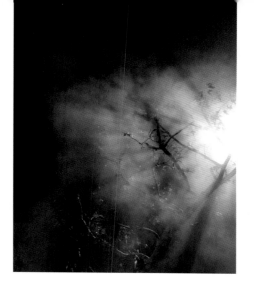

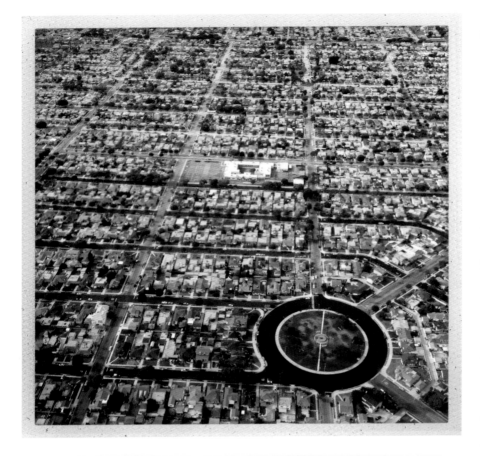

Grids (top left)

Grids only become interesting when you break them up or have very interesting content set up within the grid. Without the circle in the midst of the rectangles, this image would not work.

Screen (bottom left)

Here's another image shot through a screen—this time, from a coffee shop. There's nothing like having a window seat and letting life walk by. I should probably cut down on the amount of coffee that I drink and the number of photographs I make while consuming said coffee. But that's probably not going to change in the near future.

"There's nothing like having a window seat and letting life walk by."

■ Atmosphere (right)

This image sets up a comparison between the single stone and the mountains behind it. The atmospheric light and clouds add to the image but it really comes down to that rock. Is it a metaphor? Does it remind you of a story or image you have seen?

■ One Last Shot (below)

There is an entire beach out there, yet this is what caught my eye. It's funny how that works. Be open to life. Get on your knees or get dirty. Take chances, have fun, share a laugh, and make interesting images. Peace.

Index

Rocky Mountain High Peaks

Explore the incredible beauty of America's great range with Brian Tedesco and a team of top nature photographers. *$24.95 list, 7x10 128p, 180 color images, index, order no. 2154.*

Motorcycle Porn
PORTRAITS AND STORIES

Frank J. Bott shows you the sexy side of these beautifully engineered and adorned machines. *$24.95 list, 7x10 128p, 180 color images, index, order no. 2165.*

Rescue Dogs
PORTRAITS AND STORIES

Susannah Maynard shares heartwarming stories of pups who have found their forever homes. *$21.95 list, 7x10 128p, 180 color images, index, order no. 2161.*

Rock & Roll CONCERT AND BACKSTAGE
PHOTOGRAPHS FROM THE 1970S AND 1980S

Peter Singer shares his photos and stories from two decades behind the scenes at classic concerts. *$24.95 list, 7x10 128p, 180 color images, index, order no. 2158.*

Storm Chaser
A VISUAL TOUR OF SEVERE WEATHER

Photographer David Mayhew takes you on a breathaking, up-close tour of extreme weather events. *$24.95 list, 7x10 128p, 180 color images, index, order no. 2160.*

Bonnet House EXPLORING NATURE
AND ESTATE PHOTOGRAPHY

Photograph the grounds of a historic Florida estate—and the plants and animals that make their home there. *$24.95 list, 7x10 128p, 180 color images, index, order no. 2153.*

Hubble Images from Space

The Hubble Space Telescope launched in 1990 and has recorded some of the most detailed images of space ever captured. *$24.95 list, 7x10 128p, 180 color images, index, order no. 2162.*

Pet Photography

Kay Eskridge shows you how to design truly irresistible portraits of dogs, cats, people with their beloved animals, and much more. *$29.95 list, 7x10, 128p, 250 color images, index, order no. 2107.*

Create Fine Art Photography from Historic Places and Rusty Things

Tom and Lisa Cuchara take photo exploration to the next level! *$19.95 list, 7x10 128p, 180 color images, index, order no. 2159.*

How to Take Great Photographs

Acclaimed photographer and instructor Rob Hull reveals the secrets of outstanding lighting, composition, and more. *$29.95 list, 7x10, 128p, 150 color images, index, order no. 2099.*